EXTRAORDINARY
EVERYDAY
PHOTOGRAPHY

EXTRAORDINARY EVERYDAY PHOTOGRAPHY

AWAKEN YOUR VISION *to* CREATE
STUNNING IMAGES WHEREVER YOU ARE

Brenda Tharp and Jed Manwaring

AMPHOTO BOOKS

an imprint of the Crown Publishing Group // New York

Copyright © 2012 by Brenda Tharp and Jed Manwaring

Published in the United States by Amphoto Books, an imprint of the Crown Publishing Group,
a division of Random House, Inc., New York
www.crownpublishing.com
www.amphotobooks.com

AMPHOTO BOOKS and the Amphoto Books logo are trademarks of Random House, Inc.

Library of Congress Cataloging-in-Publication Data

Tharp, Brenda.
 Extraordinary everyday photography: awaken your vision to create stunning images wherever you are
/ by Brenda Tharp and Jed Manwaring. — 1st ed.
 p. cm.
 Includes bibliographical references and index.
1. Outdoor photography—Amateurs' manuals. 2.
Photography—Technique—Amateurs' manuals. I. Manwaring, Jed. II. Title.
 TR659.5.T46 2011
 778.71--dc23

 2011040810

ISBN 978-0-8174-3593-6
eISBN 978-0-8174-3594-3

Printed in China

Design by Kara Plikaitis

10 9 8 7 6 4 5 3 2 1

First Edition

To all those who have inspired us to see more deeply that which was right in front of us,
and to each other for mutual support in the "dance" of life

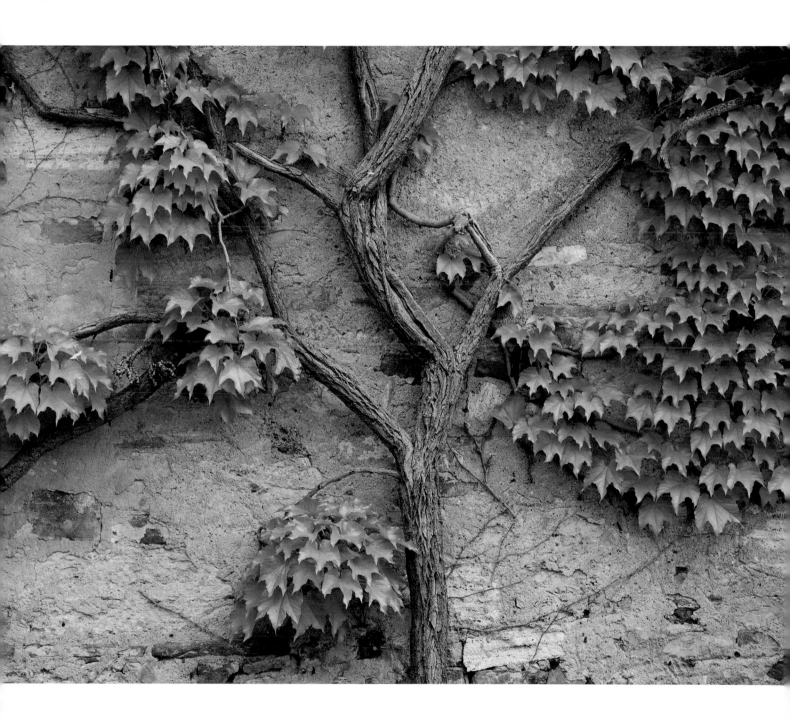

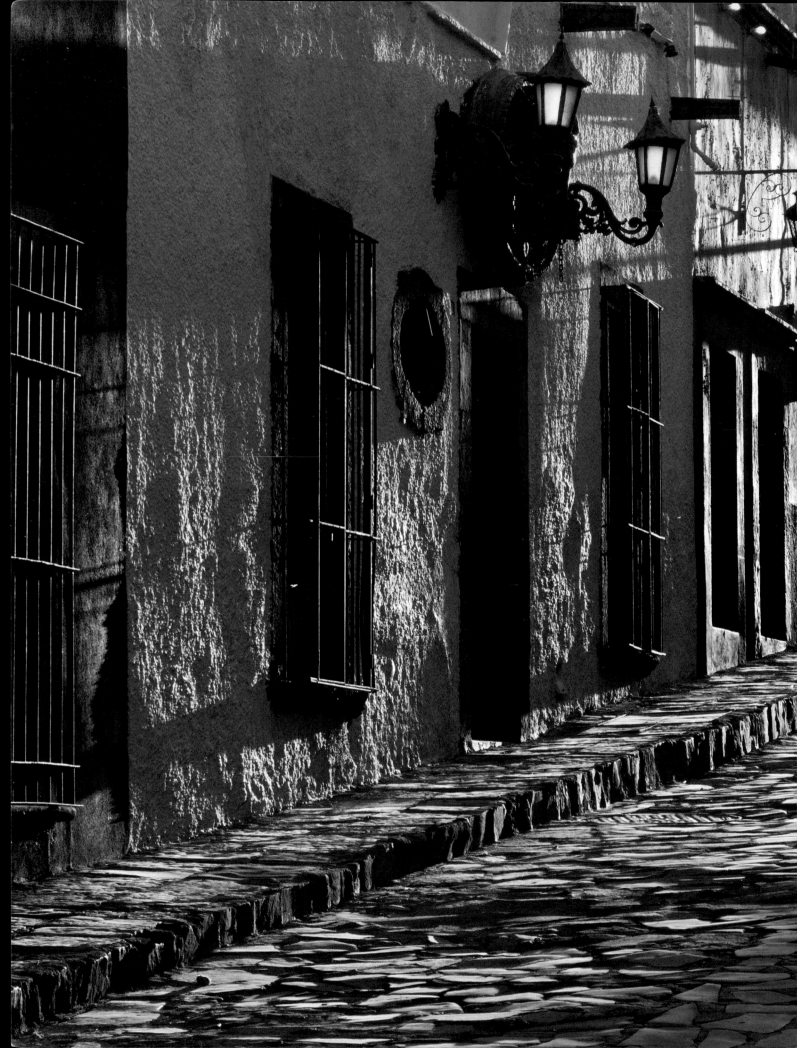

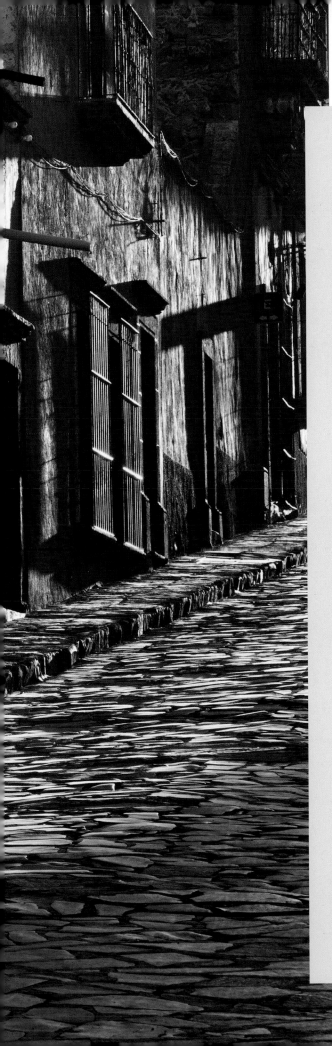

Contents

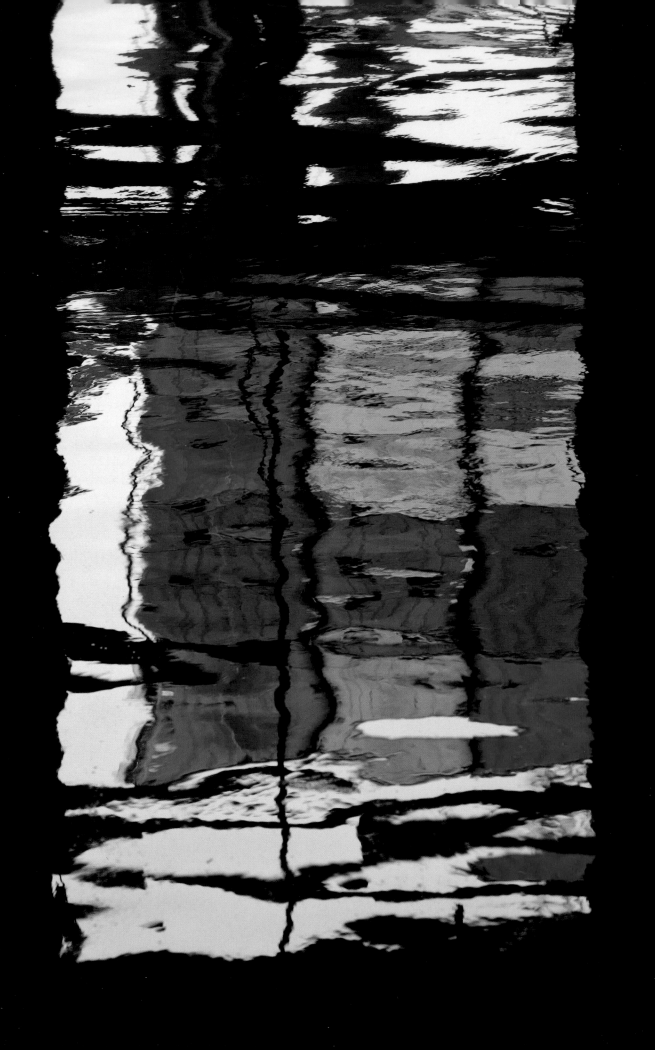

Introduction

PHOTOGRAPHERS ARE A TRAVELING bunch. We go places to capture the light, the landscape, the wildlife, and the people. Many photographers travel quite a distance to make their pictures, seeking out exotic locations. But do we *have* to go far to find interesting things to photograph? Some of you would answer with a resounding "Yes!," and for certain types of photography—wild animals, unique cultures, and so on—you would be right. However, wonderful images are hiding almost anywhere, if you just look. We are willing to bet that you can make great photographs near where you live, no matter where that is.

There are many books on the basics of photography and digital technique, but few that write about using the heart along with the mind to make great pictures. Almost anyone can master the basic skills with today's digital cameras, but will those images have meaning? Photography isn't just about the mechanics of setting aperture and shutter speed, and pressing the shutter release. It's also about figuring out *what* you're trying to express in your picture, and *when* to press the shutter button. To do this we must have a creative vision that comes from seeing with an open heart and mind. We opened a Chinese fortune cookie while working on this book, and the fortune inside couldn't have been more perfect! It said, "We see with our heart and not with our eyes." Was that a sign?

70–200mm lens at 200mm, f/9 for 1/80 sec.

We got the idea for this book after talking with a dear friend. As an amateur photographer with a never-ending passion for developing her creative vision, she told us that many more pictures in her camera club competitions were from faraway places than the areas around home. She admitted that she, too, had traveled a great deal, and to fairly exotic locations, to photograph. Yet she had come to realize that she wasn't experiencing her own culture, her own "exotic" location, as much. She decided to change that by exploring her local neighborhood, and she began to see things she hadn't seen before: the way the wisteria draped over the park fence in springtime, the tree shadows that the afternoon sun created on the wall of the grocery store. She made playdates with herself and photography friends to go someplace each week, within reasonable proximity to home, to see what they could find. She was seeing photographs everywhere and having fun, and her photographs were different and fresh.

What had changed? She was the same person, with the same physical vision. Yet she had begun to look past a lamppost as being just a lamppost, and instead saw its shape, or its shadow on a wall. She didn't care if her picture was of a bench; it was the way it looked in the sidelight or the color contrast of it against a painted wall. It was not the thing itself but what light and geometry had made it become that interested her. This is a true story, and it resonated with us as we talked. And that's what got us started on this book. In addition, we each had our own personal reasons for wanting to write about creative vision.

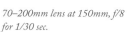

B | *70–200mm lens at 150mm, f/8 for 1/30 sec.*

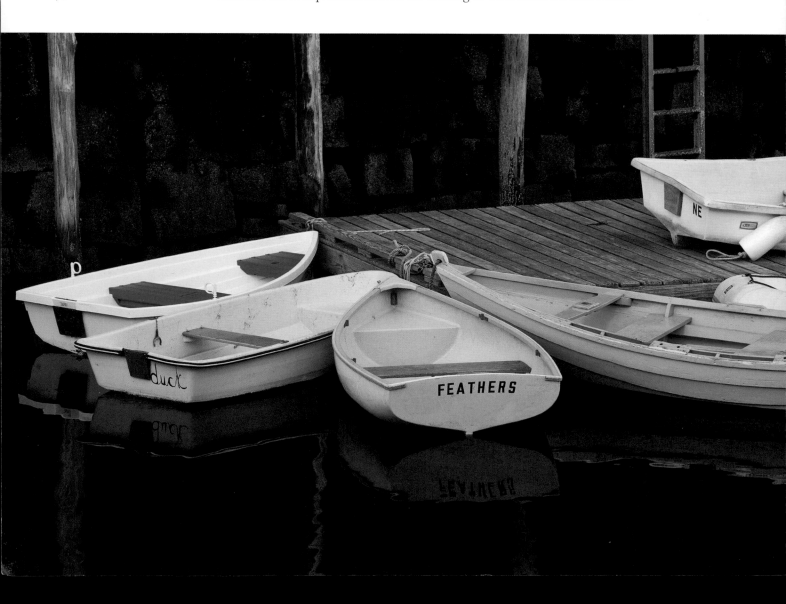

BRENDA

My dad had a strong work ethic. He was always busy with some project. It's something I inherited and perfected—perhaps to a fault! While I'm thinking of the next task I have to get done, or planning where I'm going to photograph, Jed is looking at the shadow his cereal bowl and coffee cup make on the table. He's always had the ability to lose himself in the moment while seeing something wonderful right in front of him. I've learned how to do this more from him. Yet while my dad may have been a bit structured, he and my mom were the reasons I got started in photography. Our camping trips and explorations involved long car trips, and a game we'd play to keep busy was "a half-penny for the first one to spot a brown cow, or a gray barn." It was a great way to get us really looking at everything we passed. That habit continues today. Instead of reading magazines or doing work on my laptop when I'm traveling, I'm looking out the window and enjoying the beauty. Photography allows me to share my feelings of "Look at that!" with others.

JED

When I was young, I used to help my grandmother put together her travel slideshows. I would often ask, "Why did you take that picture?" She would smile and tell me that it was needed to tell the story of where they had been. But occasionally she would just say, "Yes, isn't it a wonderful image?" And I had to admit that it was. Although I didn't understand why, I liked it. It touched something inside of me that I couldn't express in words. Now, as I pursue my own photography, I have always tried to keep that connection to things I see, to react almost instinctively to an image and then, only after I have recorded it, to fine-tune the technicalities. When I picked my favorite of her images, my grandmother would often reply, "I like that one, too; you have a good eye." True or not, this was an affirmation of the way I saw things and it encouraged me to continue developing my personal vision. As a kid, I traveled with my family around the West, seeing wondrous things, and my father and mother always encouraged me to explore and gave me cameras to record what I discovered. It was the basis for my choosing a career in photography and teaching others to discover beauty, too.

Not every picture we make will end up in our fine art collection, or even be published, no matter which camera we use. As photographer Chase Jarvis said, "The best camera is the one you have with you." Sometimes it's impractical to carry large cameras, so our compact digitals and phones are always with us, allowing us to capture life's moments and gifts without having to make huge megapixel files. To us, what is more important is that we saw it, experienced it, captured it, and can share it with others as our ongoing celebration of what is great with this world. It's all about making a picture because we like what we see, or because it's a funny juxtaposition or moment. That said, even an iPhone picture can print nicely at 8 × 10 inches, and we've even signed on to a stock agency for submitting iPhone pictures! Roughly 90% of the images included in this book were made using Canon and Nikon digital SLR cameras (DSLRs); the remaining pictures were made with compact point-and-shoots and our iPhones. We included the camera model information on those pictures to prove that great images can be made with any camera, if you are seeing creatively.

In our workshop and lectures we often hear people say, "There's not much to photograph where I live." And we wonder: *How is that possible?* We see things all the time, things we can't always photograph, but we can still see them. It is essential to go out and let the world show you its visual gifts. The present really is just that: a present. We must learn how to appreciate it as a special, fleeting gift. Our goal in writing this book and sharing our ideas and photographs is to reawaken your interest in the things around you and your world, and to prove that there are artistic photographs to be made just about anywhere you are.

Some of the pictures in this book may seem beyond the everyday, but because we live in San Francisco's Bay Area, our "everyday" is often a visual delight. We have also included a few pictures beyond our home area, but these reflect either what we'd find near our home or, better yet, what you might find near your home. We just happened to find some of them while on the road, teaching workshops in places we've been to so many times that we consider them a second home. The point is that these pictures still illustrate our ideas—a harbor in northern California is pretty similar to a harbor anywhere—and we hope our images will inspire you to seek out places near you as new destinations to explore your vision.

Some of you might challenge our ideas, thinking, "How can you really find beauty in a fence post?" Get over that hurdle of disbelief; you'll find out for yourself by the time you finish this book and do the exercises in it. We're serious about playing.

In addition to pushing you out the door to check out your own backyard, hometown, and neighboring areas, we've included chapters on subjects that are fundamental to any good photograph: light, point of view, and composition. We've added ideas for photographing your area at night and in low light, and for loosening up, too, using special techniques that can move your pictures to a new level. All of this is aimed at helping you capture the awesome world around you. So, open your mind and your eyes and read on!

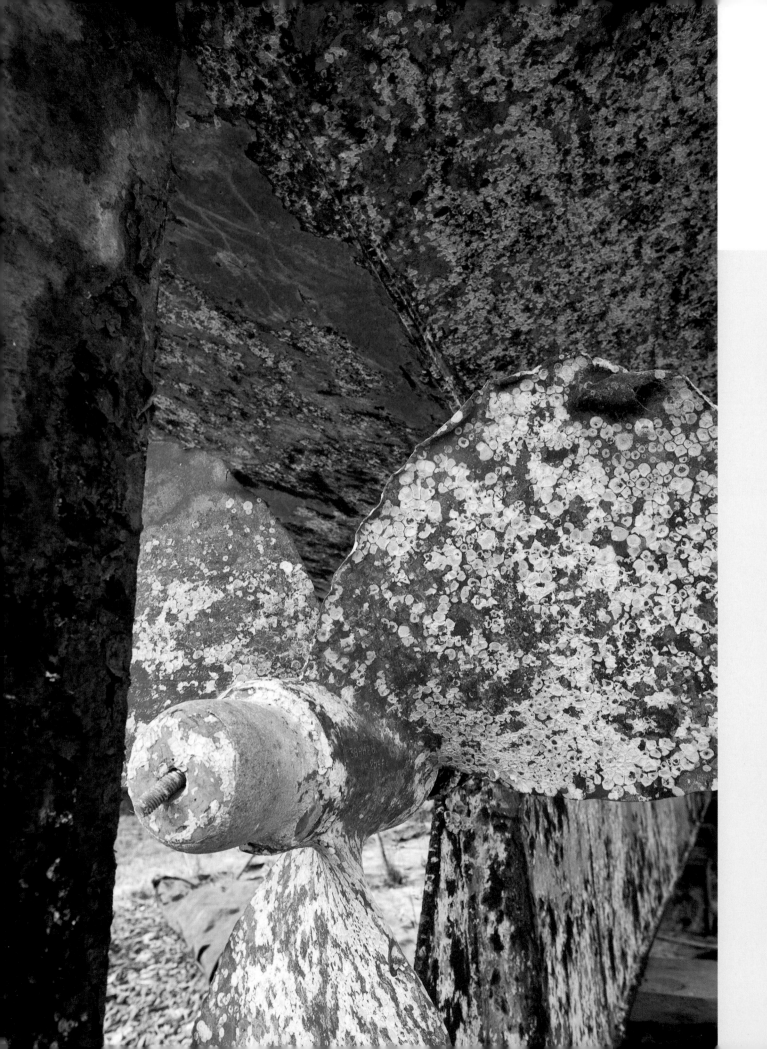

Finding Fresh Vision

WE'VE HEARD IT ALL in our workshops: "I don't see anything interesting around my neighborhood." "I'm too busy to go out and make pictures when I'm home." "I get more inspired when I travel to other places." We understand that last one—both of us love to travel, and do so to experience new places and cultures. But making great photographs doesn't require you to go great distances or head to exotic locales. Your own environment is filled with photographic potential, both inside your home in the area surrounding it.

Just take a look at some of the great classic photographers' work and you'll see what we mean: Edward Weston's *Pepper* series, Ansel Adams's images of his "backyard" of San Francisco and Big Sur. Henri Cartier-Bresson worked the streets of any city he was in. And Claude Monet painted many pictures of the same haystacks, as well as of his garden at Giverny, because he kept seeing more deeply and *feeling* more deeply about his subject. It's a process many artists practice—painting, sculpting, or photographing the familiar. And it just makes sense. When artists study a scene and paint it over and over again, they get to know it intimately.

J | I discovered this old rusty propeller and hull in a boatyard. The pattern of rust and paint looked like an abstract painting. My challenge was keeping distracting elements out of the frame. I tried using a telephoto lens to narrow my field of view but couldn't get the depth of field I needed, so I switched to my 24mm. By getting close, crouching down, and looking up slightly at the underside of the hull, I was able to frame the subject so the image was filled with textures and colors from the rust and barnacles, but without any distracting background elements.

24mm lens, f/8 for 1/80 sec.

B

You never know where you're going to find photographs. I visited a botanical garden to make pictures, and all around me were these wonderful displays of flowering shrubs and plants. But as I was walking down a path, I noticed this one purple blossom lying on a drainage grate, and it cried out to be photographed. This flower had fallen off the plant and was about to fall into the dark abyss of the drain. Poised for a short time on the edge, it provided such a great contrast to the hard, rough grate. It was the last chapter in the life cycle of this flower.

70–200mm lens at 189mm, f/11 for ¼ sec.

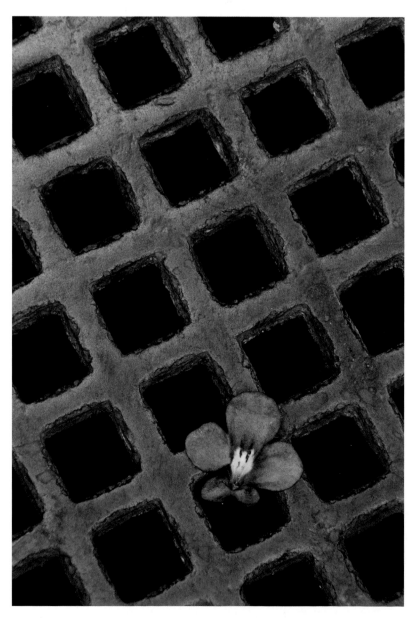

They know the way the light falls on the objects in the scene; they see the differences in morning or afternoon light and how it changes the texture of the scene. They notice the way the tree leans to the right side and how this affects the overall composition.

American naturalist and essayist John Burroughs said, "To learn something new, take the path you took yesterday." We can all get lucky with great light in a dramatic landscape one time, but imagine the odds if you revisit a location over and over? If you visit the same place often, you will come to know it more, and you will make more meaningful, personal photographs of that place. The same is true when revisiting an object, such as a familiar tree or building. We can all see a flower as we walk past the garden. But then there is seeing the flower in such a way that we notice the shape of the petals, the subtle shading of the colors, the dewdrops glistening on the edges of the blossom. The second form of seeing is experiencing the flower, and the more you learn to do that with any subject matter, the better your photographs will become.

Even if there is great value in photographing the familiar, it's a common feeling that it's better "over there," and so you go in search of something that will excite, inspire, entertain. The newness of a place does inspire, but if you see the potential only in other places, you are missing the value of what's right here in front of you. If you don't think there's anything there, think again! Our "familiar" is fresh and new to someone who's never seen it before. How often has it happened that friends from out of town ask you for a local tour, and while showing them around you discover places and things you hadn't noticed before, or hadn't really looked at in a while, because now you're trying to see your town or city through new eyes? A woman from Asia on a western U.S. photography tour we were leading made very different pictures of the same scene we were all working with because she saw everything with fresh vision, it was all new to her. You'd probably do the same if you visited Asia—but the challenge as artists is to find something interesting in the everyday, familiar things around you.

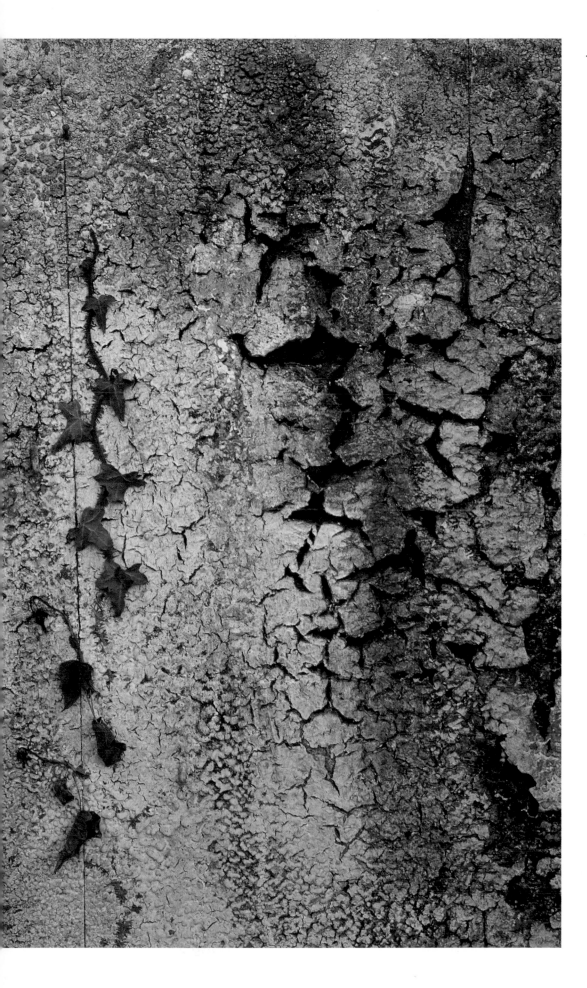

J | One morning while exploring a small town, I came across a lovely old garage door set in a stone building. I really liked the weathered blue paint, but couldn't find a composition that worked of the whole door and building. I got closer and started really looking at just the door. That's when I saw the vine. The pattern of the vine is echoed in the pattern of peeling paint. The two combined expressed the essence of that old door for me.

105mm macro lens, f/11 at 1 second

CELEBRATE YOUR WORLD

B | It's incredible that the inside of many fruits or vegetables has such great design, since that doesn't make it taste any better. I've photographed slices of peppers, kiwi, and oranges, and one day I decided to photograph red cabbage. I made several photographs, as with each new slice another design emerged. This one reminds me of a crab, or a scorpion.

100mm macro lens, f/13 at 1 second

Marcel Proust used to say, "The only real voyage of discovery consists not in seeking new landscapes, but in having new eyes." If you are to see with new eyes, as he suggests, you'll need to look at everything around you with the curiosity and wonder of a child. You'll need to fall in love with the world right around you more. When we go out with camera in hand, we carry a sense of hope that we'll discover something really exciting to photograph. We're excited about what we might find, and we trust that we will find something of interest, if we look deeply enough, so we can share what we've discovered with others.

To freshen your own vision, begin looking at everything around you more intensely—really looking. Study an object or a scene in detail. Pick an object in the kitchen—fruit or vegetables, for example. Have you ever noticed the wonderful design inside a head of red cabbage as you cut it up to make coleslaw? This can be the beginning of your expanding vision, and you won't even have to leave the house!

No matter what you're doing, pay attention to everything and try to be present in the moment. If you take out the garbage at night, notice what kind of night it is. Is it cloudy, or clear with stars? Is the moon up? While watering the garden, notice how the drops of water hang off petals or are caught in the hairs of a plant. See the way the light comes through leaves. When you're driving, take notice of what you see along the way. Do the shapes of the downtown office buildings create graphic images against the sky? Are there repeating rows of crops in a field? Are there incredible ripples of reflection in a local pond? Do the summer flowers wave in the breeze in the median strip? If you commute via train or bus, you have even more time to look around you. Are there great reflections in the glass-windowed office buildings along your route? Do the shadows of cars and pedestrians create interesting shapes on the street? Are there joggers, cyclists, dog walkers, or other people you can observe? What about the way the light streams through the trees, shadows that fall on walls and sidewalks, or the blur of passing cyclists? If you're stuck in traffic, notice how the light reflects off the chrome of

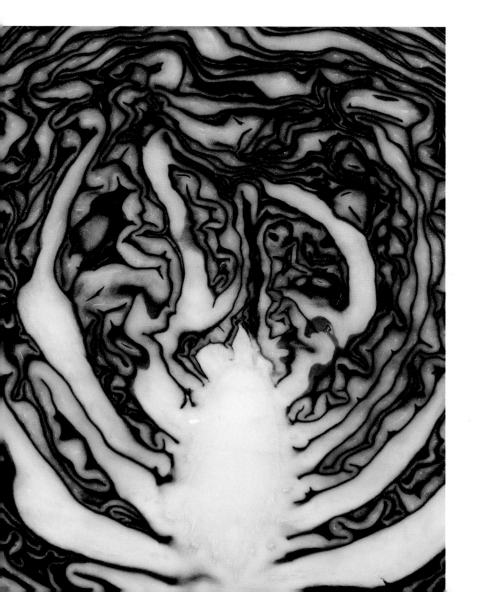

nearby cars, or how the line of cars in front of you creates a repetitive pattern down the road. Look at each driver framed in his or her car's window as an individual portrait, a snapshot in time. Just tune in to things around you, and you'll begin to see many things of interest. And *that* prepares you visually for making better pictures.

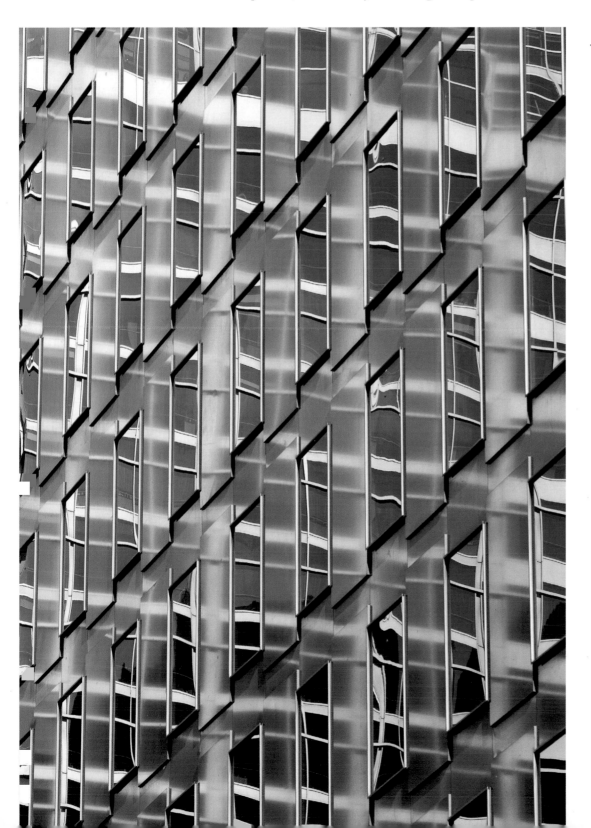

J I was in downtown San Francisco one morning when I noticed how these two buildings merged together visually to create a very unusual effect. I used a telephoto lens to isolate just a section of one building with the adjacent building reflected in its surface. Because there is no horizon or reference point, scale and dimension are missing, and it becomes an abstract pattern filled with lines and shapes.

70–200mm lens at 195mm, f/7.1 for 1/320 sec.

PRACTICE SEEING DAILY

B It always pays to look closer. We had stopped to photograph a lovely red barn with a wheat field in front of it, but then I spotted these tiny flowers. The climbing vine had wrapped its tendrils around the wheat, and I loved how they were intertwined, expressing a story about how nature permeates our manmade lives. Backlit by the morning sun, the wheat and blossoms glowed. My telephoto lens allowed me to isolate the flowers to make them stand out.

70–200mm lens at 100mm, f/7.1 for 1/100 sec.

It's not always practical to make a picture, but we all know that the best pictures are the ones we see when we *don't* have our cameras, right? So let go of that, and make "neuro-chromes," as a good friend once called the pictures you see but can't record. Make pictures whether you have a camera with you or not. Focus on, or frame, the things you see around you so they become pictures in your mind's eye. The more you do this, the more your vision will develop and the more you'll see neat things when you *do* have a camera. It works; trust the process. When we see a great moment or scene that we can't photograph, we say "click"—and it's recorded in our mind's eye and brain. These become sketches, filed away under "things to look for again" in our brains. We believe this helps us see other, similar opportunities more easily because we already have a mental reference file on it. If nothing else, the process keeps our observation skills honed.

Make Every Day an Artistic Day

When we separate our artistic activity from daily life, we cut ourselves off from our most valuable creative resource. However, if we live life as an art form in itself, we have available to us all that we experience and see. Creating a life that has positive experiences—adventure, love, humor, and a deep sense of wonder—will filter how we see the world around us, too. Ansel Adams felt that pictures were made not just with a camera, but by viewing the world through the filter of all the pictures you saw, books you read, music you heard, and people you loved. Create a life that has quality experiences in it, and your pictures will become more meaningful.

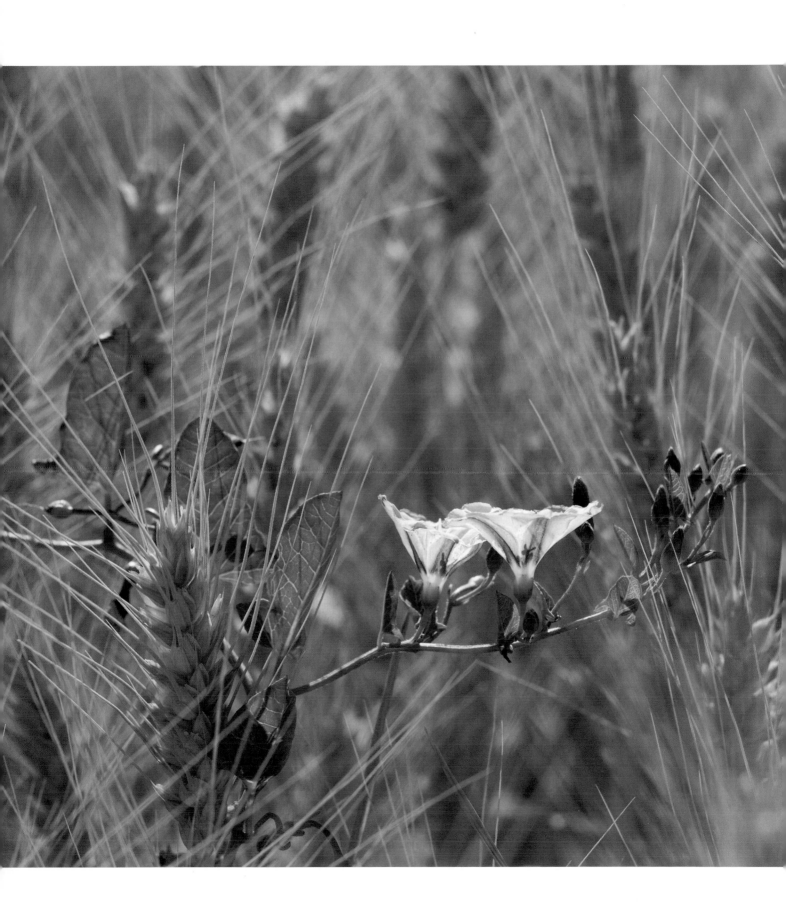

See beyond the Subject

B

this page: One day I was wearing a turquoise pullover and the colors reflected in the cheese grater I was washing. Intrigued, I got out my macro lens to photograph the pattern and colors. When I looked through the lens, the shapes reminded me of a fleet of bulletlike spaceships from a sci-fi movie!

100mm macro lens, 1.4× teleconverter, EF 12mm extension tube, f/16 at 1.6 seconds

opposite: Jed was thinking of doing something with a bunch of discarded DVDs, and while they were sitting on the kitchen table, I saw the wild colors reflecting in them. When I tried my 100mm macro lens and got in close, I lost the reflections. The solution was to use my macro lens with a teleconverter to magnify the image, and an extension tube to let me focus closer, allowing me to get just the right angle to pick up the reflecting light.

100mm macro lens, 1/5× teleconverter, EF 12mm extension tube, f/16 for 1 second

Many people's reaction to a rainy day sounds something like this: "Oh, it's a nasty day; everything is going to get wet on my way to work." But to a child, a rainy day means puddles to jump in, raindrops to catch, and the possibility of rainbows. And to a photographer, those puddles, raindrops, and stormy skies with rainbows can mean great photographs, if you're looking at things for their positive potential. "Seeing more" often means acquiring a new attitude. If you believe there is beauty and interesting stuff all around you, you will see it, more and more, as you open yourself up. You just need a willingness to explore and find what's extraordinary in the ordinary things around you. It doesn't matter what the subject is: a flower blossom, an abalone shell, a lichen-covered tree. Your goal is to get past what the thing *is*, by textbook definition, and look at it for any visual delight it might offer.

It's human nature to want to define what something is—a flower, a piece of granite, a type of tree. But more important, you need to get beyond what it is and see it more deeply. Ask yourself things like, "What does bark look like up close?" or "What are the colors in this piece of rock and what would it look like wet?" Many years ago, Canadian photographer Freeman Patterson photographed a clear paperweight he'd found in his kitchen. The images looked like he'd taken a trip to outer space, with the curve of the paperweight appearing like the curved surface of a planet, reflecting prismatic light against a dark background. When he presented a slide show of the series to a room of nature and outdoor photographers, we were enthralled. It was just a paperweight, but the color, the light, and his unique viewpoint surpassed the subject. Patterson had seen beyond the thing itself.

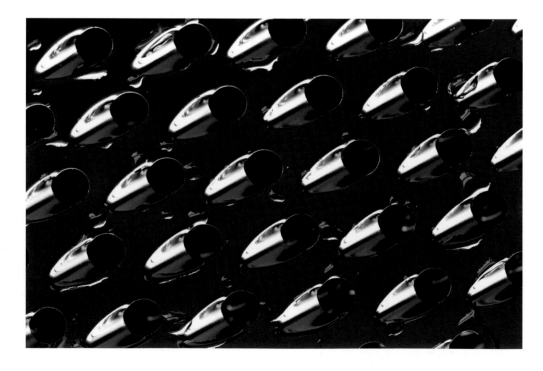

One gorgeous winter day, a family member invited us to go out on a small lake in their boat. As we were getting the boat readied, we discovered that rainwater had collected on the canvas cover and had frozen solid into one large piece. I picked it up, amazed at how clear it was. I loved how the world looked through it, so I wedged it in between the boards of the dock and lay down with my 24mm lens to make this surreal picture.

24mm lens, f/11 at 1/60 sec.

You can see beyond the subject, too, by asking yourself how you *feel* about what you are seeing. What does it express to you? Are you drawn to the subject for its texture? Its shape? Is the light expressing a certain mood? Is the scene funny, or sad? When you get in touch with what you feel, you draw from a deeper well of vision and will find ways to photograph your subject that express this. If you don't have any feelings about your subject, this, too, will be reflected in your pictures. They may end up being static, lacking expression, and possibly lacking a focal point.

The inside of your house may not seem interesting to photograph, but it's a great place to begin learning to see more deeply. Go into your kitchen and notice the chrome reflections and the design of kitchen items, their colors and shapes. If you want to make pictures, great. If not, use the exercise as a way to begin seeing the

things around you more. Or, take a walk outside and look at a tree. Notice the texture, the pattern, and the shape of the tree. Walk around it and notice how the light changes its attributes, bringing out texture, form, and shape. Or visit your garden or a neighbor's yard and look at the variety of designs in the plants and flowers.

Expanding on this idea, choose a place nearby and go there to photograph. It doesn't matter where you go; it could be the beach, a junkyard, a backyard garden, or an urban park. Ideally it's a place you haven't photographed before, somewhere you might not think of normally going for pictures. If you think there's nothing there worth looking at, then it's time to get over that resistance and go anyway, if for no other reason than to prove yourself wrong. The only rule is to leave your assumptions and expectations behind, opening yourself up to seeing what's really there. Go beyond

your left brain, which tells you, "It's only a rusty old engine," and instead listen to the right brain, which says, "Look at all those wonderful patterns in the rusty texture!" The more you can move into the right side of your brain, the more you'll see.

If you are willing to do the visual exercises above and at the end of this chapter, you'll be starting the process of developing "new eyes." We have often given assignments to workshop participants to photograph in vacant lots, woodpiles, kitchens, and so on, and it's amazing what people see and photograph during that process. Jed once asked a group of students to make twenty images, all within a 25-foot diameter circle of one spot that they chose. One student was upset and said, "There's not enough here to make that many pictures." An hour later he still hadn't returned. The group headed off to where he had gone and found him beneath the roots of an old tree that had fallen down, lost in the macro world of mosses, bugs, and roots. He was absolutely beaming and had made more than fifty images!

There are so many wonderful pictures to be made when you look at the world with open curiosity. Just imagine now how many photographic opportunities there are waiting for you within close range of your home! The potential is endless.

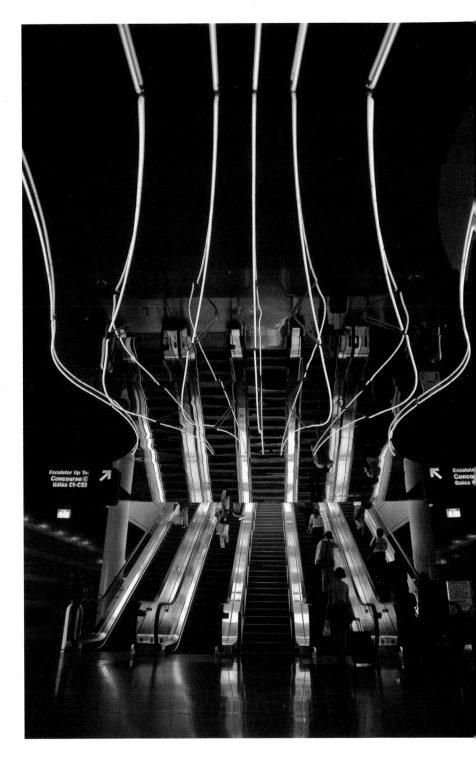

J | While waiting in an airport for our flight, I saw this wild scene with the reflection of the escalator in the highly reflective ceiling and floor. I used a wide-angle lens and tilted it up to emphasize the strong lines of the neon lights above the escalator while still including the reflective floor. You might find similar images inside corporate buildings or train stations with polished floors.

24–85mm lens at 24mm, f/2.8 for 1/30 sec.

EXERCISE #1: CHANGE YOUR LENS OR YOUR SUBJECT MATTER

Here's a great stretching exercise. If you generally use a telephoto lens, put it away and start looking at the world through a wide-angle lens for a day or a week. If you normally photograph people, go out and look for nature subjects. If you usually photograph sports, try photographing landscapes. It's all in the interest of getting you to see in a different way. If you have a friend who is into landscapes while you love macro photography, go out together and reverse roles.

EXERCISE #2: PREVISUALIZATION VS. REALITY

Before you go to a location, make a list of what you expect to find. Now go to that location and compare what you pre-visualized with what's actually there. You may be surprised, as it's almost never what you anticipated. Now push those expectations you had aside, and photograph what *is* there.

EXERCISE #3: STUDY YOUR SUBJECT

Do you have a dog, or some other pet? Take the time to really study it, and see how many different images you can make of it—not just the usual portraits, but details of its paws, its form, how it moves when it plays. Try to make an image that captures the essence of what your pet is to you. If you don't have a pet, choose a subject to photograph and really study it, making many pictures.

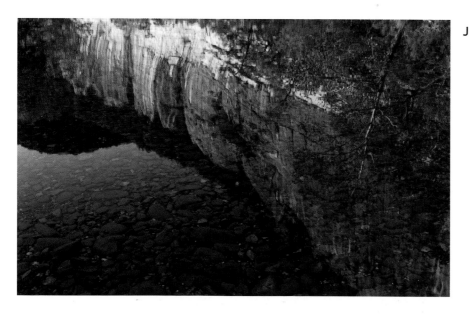

J I loved how the cliffs soared above this river. The water's surface was still enough to get a good reflection, so I composed an intimate landscape. But I wanted to include the stones at the bottom of the river, too, so I rotated the polarizing filter until I got just the right balance between the reflection of the wall and trees and the stones below the surface. Interesting reflections can be found on many rivers or lakes when the water is calm and quiet.

24–85mm lens at 36mm, f/11 for 1/6 sec.

B | *left:* Morning coffee and morning sun—a perfect combination. And when you sit down at an outdoor cafe that is this interesting, your morning coffee just might get cold. I loved how the light streamed through the glass and created a neat shadow on this table's etched surface. The red flower provided a colorful accent to an already interesting photograph. As I set my tripod up high enough to get above the scene and stood on my chair, I made my own "scene" with onlookers. But when they saw what I was creating, they were surprised. I love it when I can turn other people on to something worth seeing!

24–105mm lens at 67mm, f/14 for 1/100 sec.

bottom: As I walked around this historic hotel, I came across this amusing scene. It told a story of the room's inhabitants being determined to get fresh air despite a window that would not stay open. I loved the color palette, the folds of the soft white sheer curtains, and the texture of the window screen. I used a small aperture to keep the screen and the curtains in focus and set up my tripod to keep the camera stable.

70–200mm lens at 70mm, f/14 for 1/5 sec.

The Moment of Perception

THE APPROACH WE DESCRIBED in the previous chapter is a contemplative one—where you explore more in depth, taking time to really see your scene or subject, and reacting to what you see with your emotions as you make pictures with your camera. This method is fundamental to opening up to what's around you and seeing deeply. Yet there is another method that we love to engage in, too, one that we think is invaluable for increasing your skills of perception and continuing this opening-up process. This method has you responding reflexively to what you see with a gut reaction. You simply respond to a moment of perception in which you suddenly see something that delights or interests you. It could be color, texture, humor, the geometry of shapes—just about anything. This approach also requires a slowing down, a relaxed wandering, though when you perceive something you must act quickly to photograph it before the mind starts overanalyzing it. In this moment, you are expressing what you see and feel without adding anything, without interpreting, but only reacting.

B "It's just a swimming pool." This is the kind of thought you have to get rid of if you want to see things in a fresh way. I hadn't planned to photograph this pool, but when I walked past, my inner eye caught the juxtaposition of the colors and the shapes, and I couldn't pass without making a picture. Did you get that it was a pool right away? And did it matter what it was? Not to me—this image was just a gut response to the colors, shapes, and textures that I saw.

24–105mm lens at 50mm, f/16 for 1/100 sec.

Practicing Miksang

J

opposite: At first glance, what I saw was the contrast of these yellow lines against the shadows, but the more I looked, the more I realized there was something strange about the shadows: they weren't straight. As the shadow fell across these stairs, the lines were interrupted, creating zigzag patterns. The result is this graphic image from something as mundane as a set of stairs.

28–135mm lens at 127mm, f/13 for 1/800 sec.

B

bottom: We were standing on a private balcony overlooking the city when I looked down and suddenly saw the face in this chair echoed in its shadow. I made this image quickly as we were heading back down to meet our group—but it always makes me smile when I look at it.

24–105mm lens at 84mm, f/14 for 1/160 sec.

There is a method of photography referred to as Miksang that is similar to this approach. We are not formally trained in this method, but we've been practicing our own version of it for a long time. The word *miksang* is Tibetan for "good eye"—not a good eye for composition, but rather the ability to see with a calm, open, uncluttered mind and a soft heart. Practiced this way, vision can become clearer, you see things as they are, and the eye becomes more focused and precise, ready to strike, in a sense, the moment the photographer perceives something of interest.

Uncluttered mind. Now there's a challenge, right? Most of us have way too much running through our minds all the time. In fact, it's rather normal to have a cluttered mind. Yet, in meditation, the goal is to let your busy thoughts run through the mind and out the other side—to let

go of your hold on them—and just keep staying in the present moment. You want to become an empty vessel, allowing everything to flow into you. When applied to photography, this approach suggests that if you stay open and in the present as you walk around with your camera, you will see things differently, with more clarity. The camera can be a meditation tool as it calms the mind and helps you center. When you are totally open to the world around you, you are immersed in the moment; you are seeing things around you but also noticing the smell of the air, feeling the heat of the sun on your back, and hearing birds chirping in the trees, all at the same time. This multisensory experience increases your ability to see deeply because you are experiencing the moment more fully.

How you respond to things you see is also based on your life experiences, your natural interests, and so on. In other words, you see the world through your own set of filters. This is why two people standing next to each other will see the scene before them differently. One will be looking at the faces of a crowd of people, while the other will be looking at the shoes they are wearing. There is no "right" or "wrong" to how you see, and this process of reacting without analyzing is a way to get in touch with your unique viewpoint.

Clearing Your Mind's Eye

Try this: Go outside and pick three points in a loose triangular arrangement. Look at one object, then move on to the next, then move on to the third. Repeat this over and over again in a relaxed fashion. Eventually, your mind will begin to clear of all the extra "noise," and only those three things will become the focus of your attention. As you move your focus from one object to the next, notice what differences you begin to see between them—textures, colors, patterns, and so on. Also, what things nearby have been trying to distract your attention? What sounds have you heard? Notice those, too. By doing this you can increase your awareness and your perception of things around you.

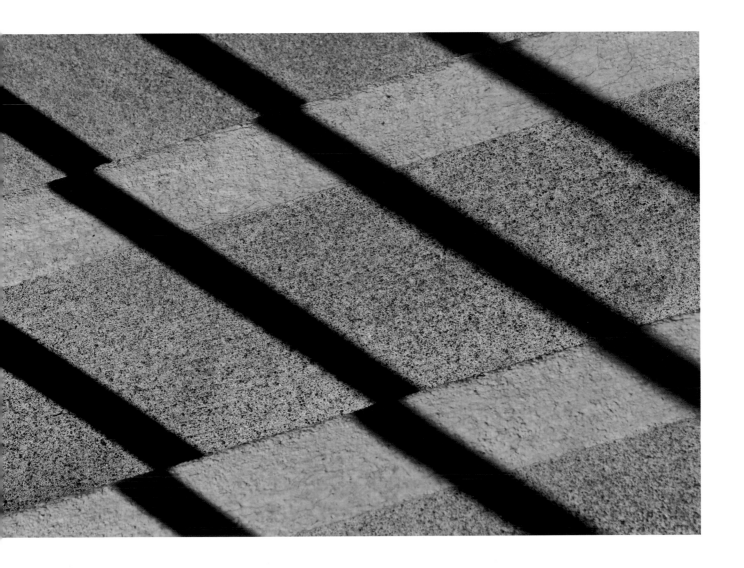

GET OUTSIDE YOURSELF

B When I walked into Jed's office one autumn afternoon, I noticed the color coming through the glass bricks in his window. But my mind's eye saw beyond it being just a glass brick to the canvas of colors presented inside the wavy glass. I quickly got the compact digital camera to capture the light and color before it went away. Then it was back to business. You have to follow when the muse leads you to a fun picture! I include the pulled-back view here (at right) to show you the mundane scene that produced such a fun picture (below).

Canon G3, f/5.6 for 1/50 sec.

It's easy to get so involved in your own thoughts and activities that you close yourself off to what's right in front of you as you rush around getting things done. If you're lost in your own world, you may not notice the child reaching up to grab hold of her mom's hand, or the dog taking a big lick of a kid's ice cream cone. You might miss the rainbow forming behind you as you drive to the supermarket, or the sunset's amazing cloud patterns. It can be hard in this busy world to go through our daily activities yet still be focused on the present, but the more you practice this, even while running errands and going about your routines, the more you'll be outwardly focused, and interesting things will begin to appear everywhere. As kids,

we played car games on family trips. One game involved being the first to spot a brown-and-white horse, or a hawk in a tree, or a blue truck. The underlying purpose was to keep us busy, but what it really did was keep us connected to what we were passing by, to seeing beyond the world of the car. Even today, when we drive along, we spot

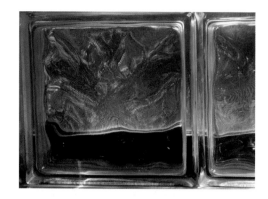

hawks in trees, the rising moon, or a wildly painted car. We point out a child splashing in a puddle, or a squirrel rustling outside a patio door. Not only does this sort of thing make our drives more interesting, but we've noticed that the more we point out, the more we see.

While you are learning to simply react to what you see, it's important to not get caught up in technique or the equipment. The artist Vincent Van Gogh said, "Paint what you see at first go." He meant that the initial emotions we feel when looking at a scene can get lost under layers of technique. This is true with photography, too. The initial connection you had with your subject can get lost when you start analyzing what lens, shutter speed, or aperture to use, or

while setting up a tripod. What's most important is your perception, your reaction to what you see in this process. Yes, Van Gogh painted using technique, but it was a practiced style of painting that he knew so well he could just lose himself in the moment of perception. If you are skilled enough to quickly change settings without getting bogged down in the technical, that's great. But if that tends to slow you down, try this approach in a simpler way. The simplest method is to use a smartphone, or a compact digital set to P mode. We like to use our phones for this type of exercise because they are easy, and we don't have the urge to control the aperture or shutter or focal length because we can't! It keeps us focused—no pun intended—on the

B This café had an incredible interior décor. As I ordered my cappuccino, I turned and saw this graphic scene. The colors were amazing, and the black vase created a contrasting rounded shape to all the rectangular shapes. I saw the composition I wanted right away. My cappuccino got a little cool while I photographed the scene, but it was worth it!

24–105mm lens at 81mm, f/20 for 1.3 seconds

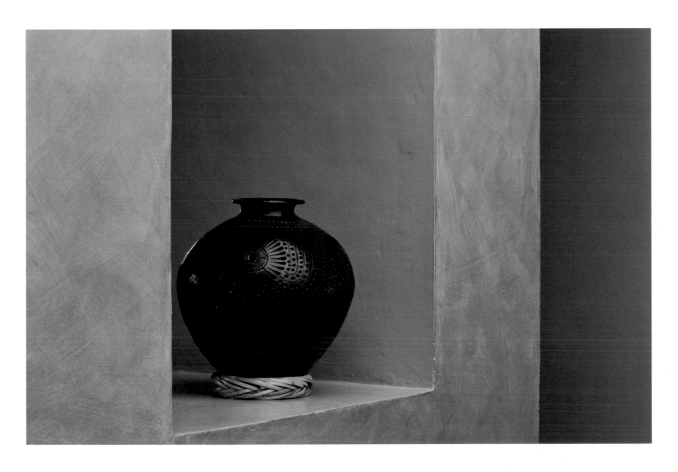

J I was photographing an old barn when I saw this pattern on a piece of farm equipment. I used my 105mm macro lens to isolate just a part of it and create this graphic image. Because I was on the shady side of the building, the dark areas, which were slightly reflective, picked up the blue in the sky, adding a nice contrasting color to the deep red.

70–200mm lens at 160mm, f/16 for 1 second

goal of responding to the moment. Yet we also practice this with our larger cameras, as often a picture we make turns out great and it's nice to have a larger file size. If you plan on using your 35mm DSLR, set your camera to Shutter Priority mode and choose a fast enough shutter speed to allow handholding without camera shake, such as 1/125 sec. for most normal size lenses. Use an ISO of 200–400 to cover most lighting conditions you'll encounter. Go with just one lens on the camera, preferably a mid-range for focal length. Being set up this way will allow you to wander and respond

to what you see "at first go," as Van Gogh suggested.

Before you start up with the "yes, but," just try it. Go out and walk around and see what catches your eye. Choose a location that will challenge you—a place you've never been before, or perhaps somewhere you pass by all the time but tend to ignore. It helps to have somewhere with a wide variety of things to see for this exercise. (You could challenge yourself with an empty parking lot, but why make it harder than you have to?) Turn off your cell phone, and go alone to eliminate

distracting conversation with friends. The fewer distractions, the better. You want to immerse yourself in the walking and seeing.

Make this a fun exercise by releasing the need to get quality results from the process. It's not about whether you make a great picture, but whether you are open to what is around you and seeing well. When you look at the resulting pictures, let go of whether the picture "worked" in terms of composition or exposure. You are operating out of your right brain during this process, and it's the moment of perception and capture that is most important. Once you get the hang of this, it's fine to let your left brain help you make the best picture possible in the moment. When we go out the door with this approach, we are always excited about not knowing what we'll see and, most often, delighted by the photographs we make.

B A flash of perception is certainly what I had when I saw this image the first time, but I wasn't ready—I had the wrong lens on my camera. As the person walked on, I couldn't stand that I had missed the moment. So I did what any pro photographer would do: I re-created it! I asked my assistant to walk along the street and snapped the shutter as soon as she was in the right spot.

70–200mm lens at 150mm, f/10 for 1/250 sec.

EXERCISE #1: PHOTOGRAPH COLOR

Make photographs about color—vivid color, color that stops you in your tracks. Go out and respond to the color you see, and try to find single colors or colors that contrast with each other.

EXERCISE #2: PHOTOGRAPH SHAPES

Make photographs about shapes—round ones, square ones, shapes on shapes. Choose a place that will give you a good variety of potential shapes. Urban, downtown areas are good, but there are other areas as well, such as boat marinas and harbors.

EXERCISE #3: PHOTOGRAPH TEXTURE

Look for photographs that are about the texture—soft, rough, hard, gritty—more than the object itself.

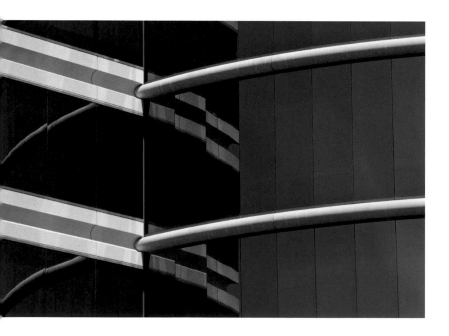

J

left: In the South Bay of San Francisco, there are these buildings, nicknamed "the beer cans," that I have passed many times on the highway. I have found them interesting from a distance, but it wasn't until I got closer with my telephoto lens that I discovered what great subjects they are for photographs. By isolating just a section of them, I turned an everyday office building into an abstract picture.

70–200mm lens at 187mm, f/7.1 for 1/640 sec.

B

opposite top: I was attending our local Japanese Cherry Blossom Festival, and the moment this woman folded her hands, I saw the picture. It was the gentle gesture of her hands just peeking out from under the large sleeves of her kimono that was the "a-ha" moment for me. When you go to events—festivals, parties, concerts, and so on—there is usually so much visual chaos. I like to slow down and hone in on details that can capture the essence of the event in a simpler way. My medium telephoto allows me to pull in those details and isolate them nicely.

70–200mm lens at 200mm, f/14 for 1/200 sec.

opposite bottom: Walking back from getting a coffee, I noticed the strong black and white of my shadow and the bridge against the cement abutment. I had my compact digital with me, and the zoom was enough to capture the scene the way I saw it. I set the camera on the wall and stood still while the self-timer went off.

Panasonic Lumix, 19.2mm lens, f/6.3 for 1/400 sec.

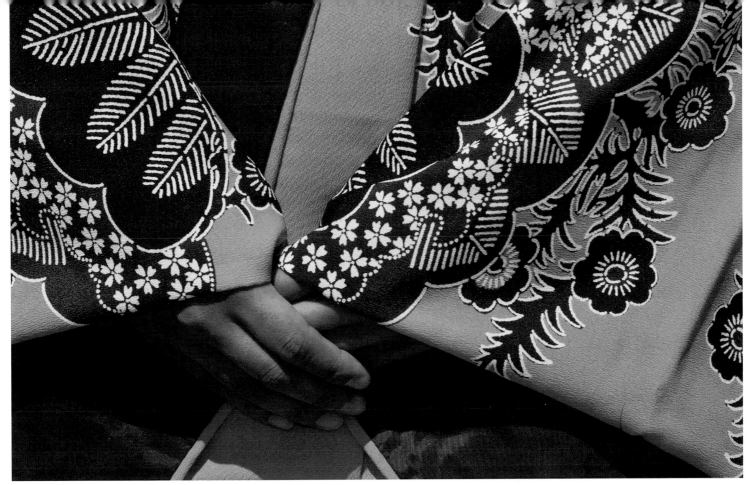

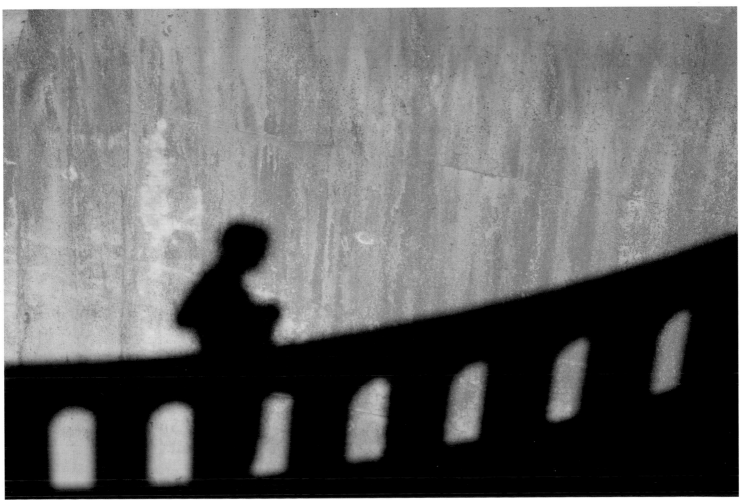

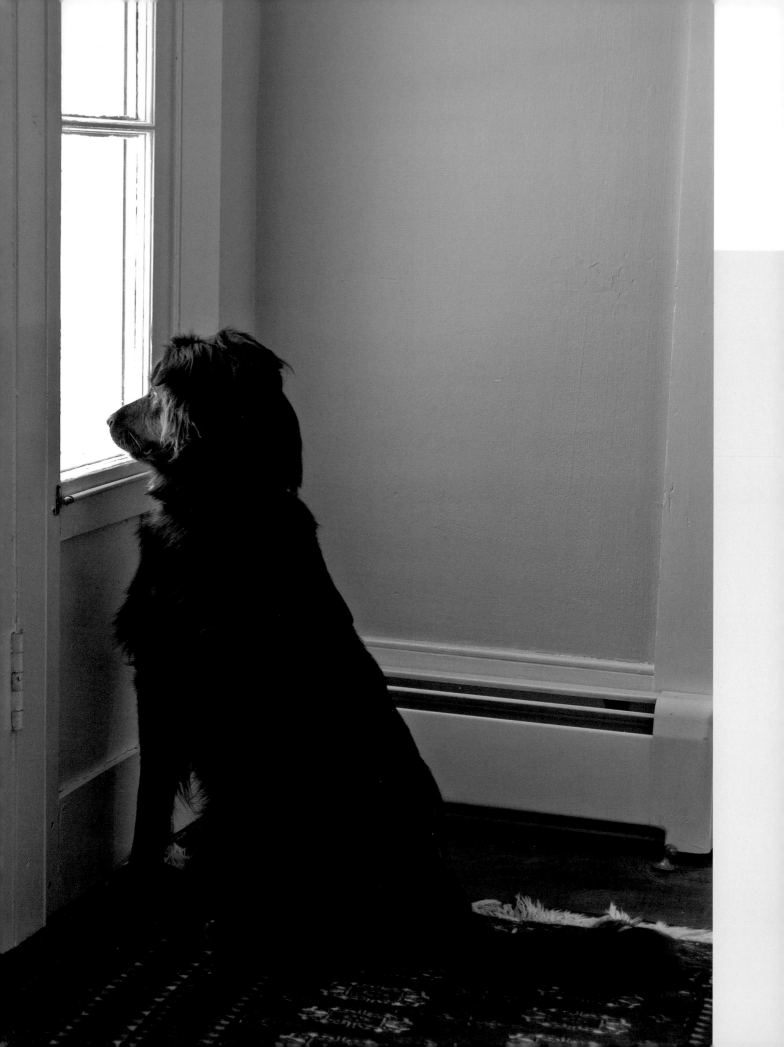

Discovering Pictures Where You Live

NOW THAT YOU HAVE some ideas about how to develop a fresh approach and vision, where can you go to find pictures near your home? The simple answer is just about anywhere. Often fresh vision comes from being somewhere you haven't been before, but that new place could simply be a new street in your town, a local park, or a college campus you've never visited before. Don't get too hung up on where to go; there are pictures everywhere. If you really want to challenge yourself, go someplace where you've been numerous times and try to see it differently.

If you only have an interest in photographing the natural world, then you may already have ideas about where you would go for pictures. National and state parks and preserves can be great sources of natural beauty, but we aren't all fortunate enough to live next door to them. However, ponds, lakes, streams, woods, and forests—even an abandoned lot in a city or town—can all provide great nature pictures, as can a local plant nursery or botanical garden.

If you are interested in the urban scene, there's a ton of photographic opportunities within any city or large town. Cities provide architectural details, contrasts of new and old, details, graphics, color, texture, and people.

J I love this picture because Maxfield's body language and focused gaze out the window tell a wonderful story of a dog waiting for his master to return, expressing the concept of love and loyalty. I used a telephoto lens from the next room so as not to disturb him and ruin the moment!

24–85mm lens at 72mm, f/3.5 for 1/60 sec.

opposite: This truck wasn't your typical "Old Rusty"! I liked how the mirror reflected the fact that its paint job resembled an American flag. It was a great example of the concept of patriotism.

17–40mm lens at 36mm, f/16 for 1/15 sec.

this page: While a group of us sat sipping coffee, I was still scanning the area for pictures and thinking creatively. I saw the cup on the counter and knew if I kept the aperture wide, I'd blur the background nicely, blending the colors and elements to make it painterly. Thus, the concept of morning coffee was photographed in a different way.

70–200mm lens at 144mm, f/4.6 for 1/60 sec.

Even if you live in the middle of farmland, you can find things to photograph. Grain silos are very graphic structures with lots of shapes, as are old wooden barns, which are quickly disappearing and being replaced by more modern metal ones. Rows of newly planted crops; plowed furrows; rolling hills of wheat, barley, and corn; the red tractor against the green field; sunflowers in a garden; the cat curled up on a wicker rocker—all of these are photographs worth making in your own creative style. If you're still thinking, "I live in a boring place," get over it! Some areas just have a more quiet beauty, a subtle beauty that is up to you to discover through your eyes and camera. There are few inhabited places on this planet that don't have something to photograph. We're willing to bet that within a 5- to 25-mile radius of your backyard, there's plenty to do. You're sitting on a lot of photographic potential if you can think beyond your normal subject matter and usual way of seeing.

You probably already have favorite places near home that you like to photograph, and it's always worth it to go back time and again, as we mentioned in chapter 1, because everything will be different each time you go. Yet consider stretching yourself visually. Go someplace you ordinarily don't go. Try going to a junkyard, an abandoned car lot, or even a salvage yard. Or consider changing your subject matter completely. If you like to photograph wildlife, try photographing people instead. If you like to do close-up nature photography, try close-up photography in your kitchen or a junkyard. It's a great way to challenge your technical skills and reinvigorate your vision at the same time.

We could have included a comprehensive list of places where you could find photographs, but that's really for you to do, so get started thinking about places in your area that might offer great opportunities. Think about places you haven't been to, but always wondered about. Brainstorm with paper and pen and make a list of things you might like to explore and where you might find them.

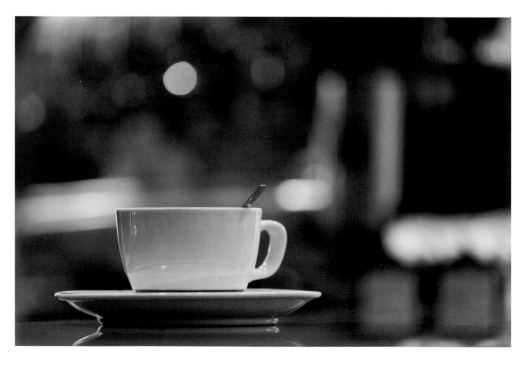

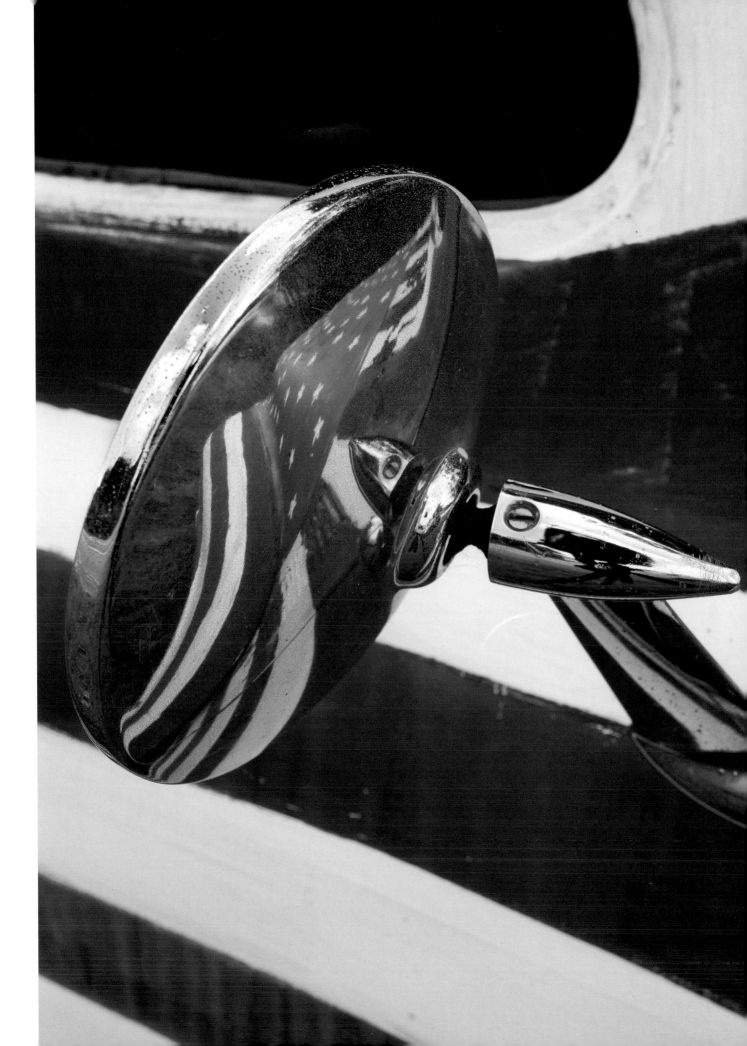

WHAT TO LOOK FOR

When you are trying to expand your vision, it can help to have some ideas or concepts to get you going. Here are a few suggestions:

- **Contrast.** Look for contrast between things that are large and small, or dark and light.

- **Juxtaposition.** Look for things that when next to each other point out a difference or similarity, or express a humorous story. For example, an old man and a young girl both sitting on a park bench eating ice cream. Or a conservatively dressed businessman standing next to a wildly painted sports fan, both cheering loudly for the same team. It might be a dinghy parked next to a giant cruise liner, or a rake next to a leaf blower. Let your imagination run wild looking for juxtapositions!

- **Color relationships.** Look for color contrast, images with red and green, orange and blue, and so on.

- **Design elements.** You could spend a whole year just photographing patterns around your neighborhood. There are also textures, shapes, and strong lines to photograph. Each of these is a worthy project in itself.

- **Shadows.** Sometimes, the shadow alone is the subject; other times, the shadow and the object that made it can combine to make an interesting picture.

- **Reflections.** Water provides incredible reflection potential, as do windows, wet pavement, shiny metal, and chrome.

- **Objects.** Begin a study of an object, such as a tree or an old fence. Choose something close by that you can return to again and again.

- **Humor.** Find funny pictures, things that tell a story without any caption needed.

- **Man vs. nature.** Look for images that show man in relationship to nature: how man has hurt or helped nature, or how nature interacts with our manmade world.

- **Metaphors or concepts.** Look for things that suggest being old or new, love, friendship, joy, risk, danger, loneliness, and so on.

- **Faces.** Photograph the faces of your neighbors, or go to a local farmers' market and make portraits there. There's a tendency to feel shy or self-conscious when turning your lens on people, but if you are genuinely interested in who they are, what they do, and comfortable with who you are, it's not that hard. Get involved with people and the pictures will come naturally.

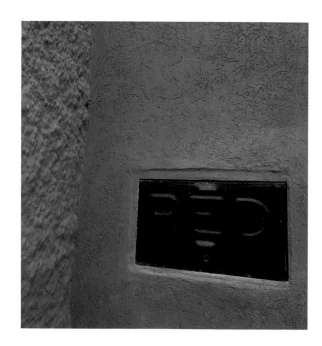

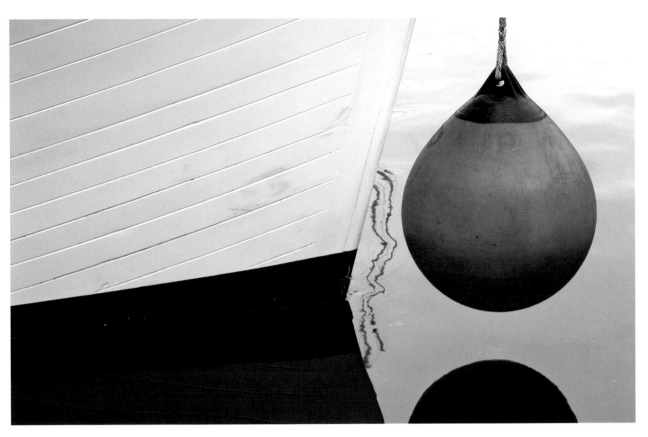

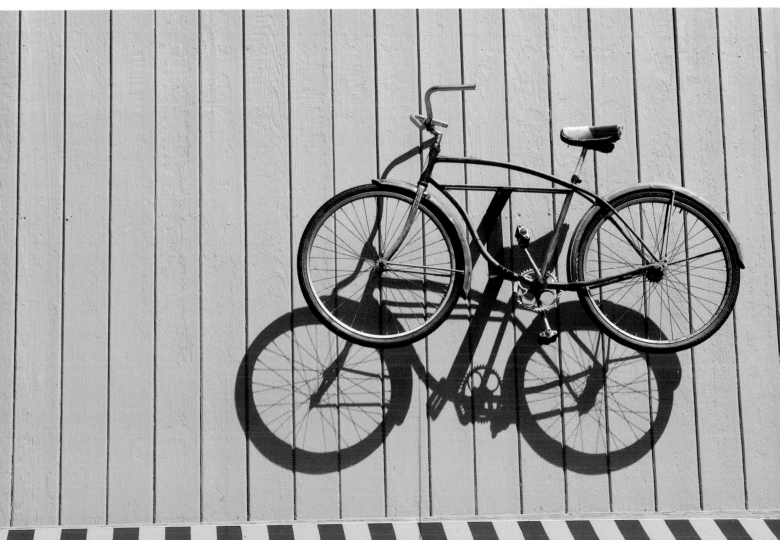

LEARNING TO SEE COLOR

B While at a small airfield, I spotted this airplane painted in primary colors. I got close and angled the camera up to set the plane against the deep blue sky, which made all the colors pop.

24–105mm lens at 55mm, f/11 for 1/60 sec.

Why is it some colors just feel right together, and others don't? Why do some colors seem to vibrate when side by side? The answer to these questions lies in the color wheel, which artists have used for a long time. Red and green, blue and orange, and yellow and violet are opposite each other on the wheel and complement each other, creating harmony if found in the same photograph. But it depends on the proportion of each color. Tiny bits of orange and blue amid other colors don't express color harmony. It's when they exist in larger proportion that they express a harmonious effect, such as in the image opposite of an orange boat reflecting in blue water.

Colors opposite each other also present color contrast. Side by side, they'll appear to duke it out to get our attention, vibrating where they meet. (Just check out orange type on a blue background to see what we mean.) In the boat reflection image, there are enough other colors and patterns to keep the orange and blue from fighting.

Bright colors advance while dark colors recede. This is why bright yellow will scream for attention in a photograph and has to be managed to be effective—unless the picture is all about a yellow object, of course.

Color theory is a complex topic that requires a book in itself, and there are good ones out there that can help you understand more. It's worthwhile to do a little reading to improve your understanding of how to make the best use of existing colors in your pictures.

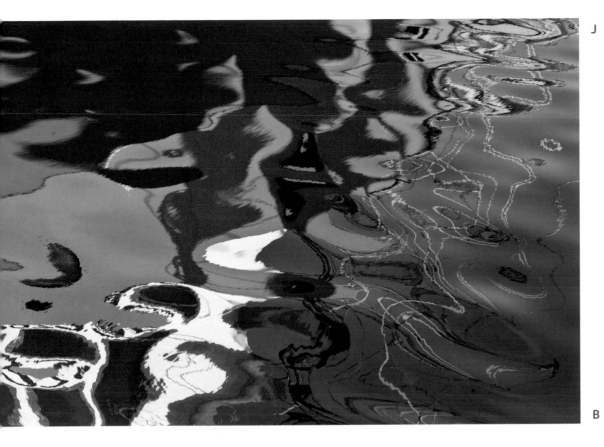

J *top:* Boats in the harbor can be fun subjects to photograph. But it was when I looked down into the water and saw these reflections that the real fun began. Because of the movement of the water and the boat itself, every image is completely different. In some there was too much orange and not enough blue. In others, I didn't see enough of the rigging, or other distracting elements came into the frame. In this photograph, there is a nice balance between the blue sky and rigging and the orange and white parts of the boat itself, creating color harmony. A medium telephoto was used so I could take out the pieces I wanted without including other distracting elements.

70–200mm lens at 80mm, f/11 for 1/200 sec.

B *bottom:* I spotted this red car against a pink and green wall. With the windshield reflecting the greens, and the pink wall behind me reflecting in the red paint, the whole thing became a study of colors and shapes.

70–200mm lens at 189mm, f/16 for 1/25 sec.

Scheduling Photography Playdates

These false hellebore plants abound in the mountains around us and are great subjects. The hairs on their leaves caught the light frost, and the overlapping leaves became a wonderful study of lines. I made this image before the sun was up and the cool color cast helped make the picture *feel* cool.

105mm macro lens, f/16 for 2 seconds

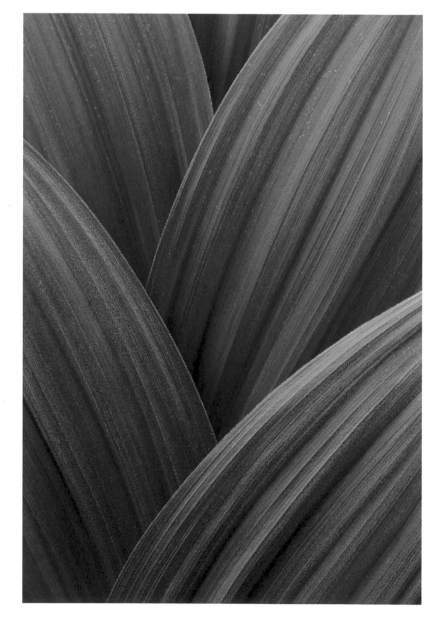

To get started finding pictures, give yourself an assignment using one of the ideas from pagew 42—but let's call them playdates, as they really are opportunities to go out and play around, to see what you can see. Once you've decided what you're looking for, ideas of where they may be found will start to pop into your head.

Or just head out somewhere without a plan and see what presents itself. Simply choose an area—such as a nature preserve, a garden, or the main street of your downtown—and start exploring. This can be hard if you are someone who is used to planning everything beforehand: where you'll go, how long you'll stay, even what types of photographs you plan to make. Yet this exercise is about seeing not only new things, but also in new ways, and it will work only if you release your expectations and relax into it. And we're willing to bet that you'll make some great images in the process.

We've got friends who say, "At least you live in a visually exciting place." Yes, we are fortunate to live near San Francisco, as the Bay Area has unlimited possibilities for pictures, but we have found that every place we've gone in the United States and around the world offers something worth photographing. We never know where our favorite pictures are going to come from, but we do know that they are out there, waiting to be discovered. It's so exciting to know that when we leave the house!

This might all sound too easy, that we just walk out the door and find great pictures all the time. The truth is, we work at it. We have good and bad days, as everyone does. We have days when we don't have a creative atom in our bodies (at least it feels that way) and can't see anything because we're tired or have too much on our minds. When that happens, we might put the camera aside, go for coffee or a walk instead, and change our focus—no

pun intended. We know that the pictures are still there; we just can't see them at the moment. Yet even when we take a break like this, we usually have *some* sort of camera with us—because it's these times when we've let go and are relaxed that we often see something. So our smartphones or compact digitals always come with us. During this process of celebrating what we see, it's not about whether the picture was made on a 21-megapixel camera; it's about the act of seeing and being open. And if we make a good photograph of something we saw, we're happy and that gets us going again. We know that when you start making forays into your local neighborhood, you'll discover interesting photographs, too.

B A local church can provide hours of inspired photography. To express the concept of spirituality, I used a Lensbaby lens to blur the edges and help pull the viewer's eye toward the cross. Lensbabies provide hours of fun creativity as they modify the light coming into the lens to create dreamy, blurred, chromatic effects.

Lensbaby lens at 50mm, f/4 for 1/50 sec.

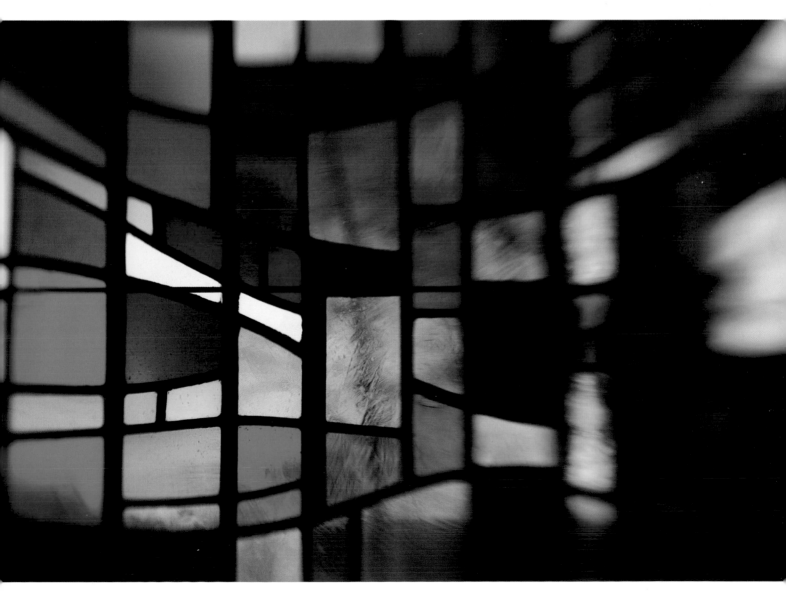

Expanding the Creative Process

AT THIS POINT, YOU'VE been exploring your neighborhood, seeing with new vision, and making some great pictures (assuming you paused in your reading to go out and photograph). Now it's time to loosen up your vision even more. Applying various creative techniques is a great way to give yourself a burst of fresh vision while photographing things close to home. You don't need any special new equipment for these ideas, just a basic camera and lenses, a tripod, and some software, such as Photoshop.

What about photographing your own street as a wide, panoramic scene? What would the old train station or the ferry plaza look like in black and white, or through the viewfinder of a Lensbaby or a pinhole lens? Special effects are part of developing fresh vision. When you are seeing something and thinking about what it means to you, there's every possibility that an approach or technique beyond a literal capture will best express what you feel. It might be panning or zooming the lens, a multiple exposure, or maybe creating several images to combine into a collage. Maybe you hadn't thought of any of these yet, and that's okay—but now it's time to push yourself beyond the straightforward image and find out if there are other techniques that resonate with you enough to include them in your creative toolkit.

B This barn and silo cried out to be a black-and-white image, since it was basically all white. I knew that the angle of light would create a wide range of tonalities and good shadows, two criteria for strong black-and-white images.

70–200mm lens at 200mm, f/16 for 1/20 sec.

B After trying unsuccessfully to capture this local hillside with single images, I concluded that a panorama was the only way to include the whole view, and I used nine vertical pictures. Here we are showing just a section of the panorama; the final print size was about 6 feet long.

All exposures: 24–105mm lens at 30mm, f/16 at 1/40 sec.

Whatever technique you choose, it should feel right for the image and for what you want to express. For us it doesn't feel right to do a dreamy soft-focus technique on an auto race. But it would feel right on an organic object: a meadow, a forest, or a bouquet of flowers. Likewise, it generally doesn't work to create a multiple exposure of things that are hard-edged, like buildings, but Brenda tried it anyway and got some fun results with colorful houses in Mexico. There are really no rules to follow, and by playing around with them all, you'll discover which techniques work better for certain subjects and which you like best. Try them with different things in your neighborhood, then go back again to perfect your image if you're close to getting what you want.

All of the pictures in this chapter are the result of asking ourselves "What if?" and then going for it, just to see the results. We do this all the time, where it makes sense. Please note that while alternative techniques like zooming the lens or using multiple exposures can be effective, when used too much they can become trite, so think about the scene carefully before you just start playing. It's conscious creativity, using a technique that feels appropriate for the story you want to tell or the feeling you want to express.

It can be a challenge to remember to try new things when you're out photographing. If you're new to photography, just getting the exposure, focus, and depth of field you want is enough mental exercise. But as you develop your

skills to the point where all of that is second nature, it's easy to get stuck in a visual rut. We are creatures of habit. Brenda used to carry around a 35mm panorama camera in her bag, but she'd often forget to take it out, being so caught up in the moment and the comfortable format of her standard 35mm. She didn't see that "wide view" naturally, so it took time to develop an eye for it. She created a little tag reminding her to "use the Xpan" and attached it to her tripod. Soon that tag included the words "panning, Orton effect, multiple exposures, black and white." After a short time, she didn't need the tag to remind her, but it helped her break out of the habit of doing the same old thing, to visually stretch and consider different techniques after she had made the image she first imagined.

Here are some creative ideas to help *you* remember things you might do, to express the subject in a different, perhaps more creative, manner. This chapter is not intended to be a complete how-to for everything you can do with your pictures. It's intended to spark your imagination, to inspire you to push your vision even further. Make a list of these techniques, laminate it, and attach it to your tripod or carry it in your pocket when you go out to photograph. Refer to it often. It can help you develop your ability to see beyond the literal image. One of these techniques might be just the thing that gets you excited about photographing that same old tree in your neighborhood one more time, expressing it in a whole new way.

Your World in Black and White

B While driving down a country road, we spotted this tree and the great clouds and shafts of light behind it. But I just wasn't able to turn the scene into a great color image, as the dark green leaves and trunk went too dark when I exposed to keep the sky from overexposing. Later, in the computer, I was able to create a strong black-and-white image that expressed the mood of the scene and the drama of the wonderful sky.

24–105mm lens at 24mm, f/16 for 1/100 sec.

Seeing and photographing in black and white can give a whole new feeling to pictures you've been making near your home. You don't always need high-contrast light, but you do need a wide range of tonalities to create good black-and-white pictures. Otherwise, objects and spaces can blend together too much, and the effectiveness of the scene is lost.

It can take practice to see the tonality of colors. But for black-and-white images, it's all about tonal values, not color. Think of tonalities as shades of a color. A medium shade of green has a tonality similar to that of a medium shade of red or blue, and therefore might not separate well in black and white, but darker and lighter shades will. If you squint your eyes down to a point where colors are almost gone, you can see the tonalities better.

How do you tell whether your scene will be good in black and white? Switch your camera to JPEG mode, choose the monochromatic setting if you have it, and make a quick picture. You'll be able to tell pretty easily whether the image will work. Or, just take a risk—make the picture in raw mode, and decide to keep it or to delete it later, after converting it on the computer.

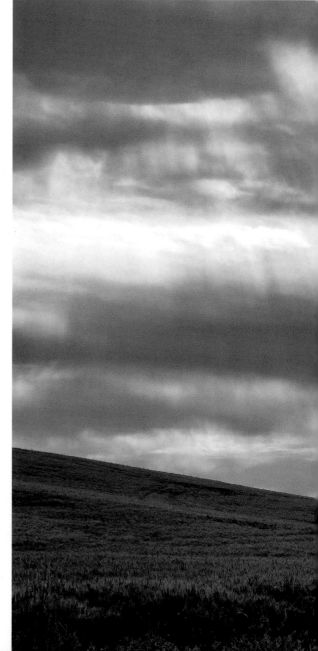

Visualize with Effects in Mind

While making a picture, it can help to have an idea of what you might do with it later. For example, if you're photographing a scene that is high in contrast, think about making it black and white. With that in mind, you can pay more attention to tonality in the image, even though you are seeing the scene in color. Or, you might be looking at a garden and thinking about applying a dreamy glow. If so, avoid too much white in the picture, as it will grab the viewer's attention even more when it's blurred. If you are thinking about adding a texture overlay to a scene, leave more wall space around an old door, or sky around a tree, because if you don't have negative, empty space in the picture, the texture can be hard to see.

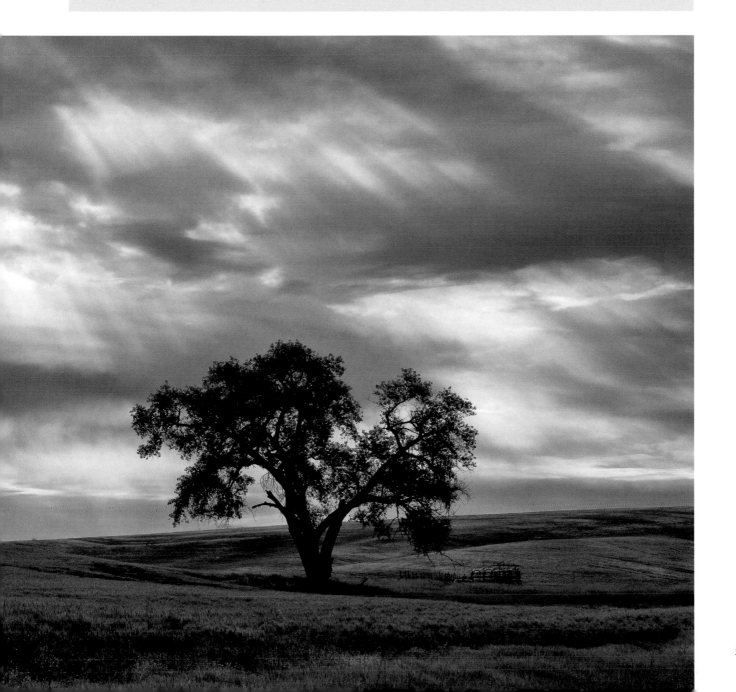

TAKE A WIDER VIEW: PANORAMAS

This wall held an incredible collection of old farm tools, most of them handmade, and it was about 40 feet long! To photograph it I knew I'd need to make a panorama. To capture the entire wall, I made twenty images, overlapping each of them. The final picture was about 10 feet long; here you can see one section of it.

all exposures: 70–200mm lens at 70mm, f/16 for 1/8 sec.

Think about the possibilities of making panorama images of things around your area. It's a great way to capture the breadth of a scene that just won't fit within one 35mm frame. Panoramas work well with mountain ranges, city skylines, streets, waterfronts, and beautiful scenes over the prairie. You can make vertical panoramas, too. Tall redwood trees, grain silos, bridge towers, and skyscrapers are great subjects for this. Look around your neighborhood the next time you take a walk and see what might be a good subject for one. You can make them using any type of camera—we've done them with our iPhones, compact digital cameras, and DSLRs. You might feel that panoramas are too complicated, but they're really not anymore. Yes, if you wanted to stitch three rows of seven pictures each, *that* could be complicated. But a single row of six to eight pictures stitched together is an easy way to experiment with a new idea.

Here's how to make a panorama:

1. First, level your tripod. Then level your camera on the tripod. Loosen just the panning screw on the tripod head. Take some practice swivels from left to right and keep adjusting just your tripod and camera until you get a pretty level movement when swiveling.

2. Compose your scene wide enough so you don't lose anything critical at the top or bottom of the scene when you crop the final stitched picture. Now, determine how many pictures you'll need to make to cover the entire area by moving your camera a bit at a time from left to right, overlapping each scene by 50%. Make note of how many pictures it took to complete the whole view in your test run.

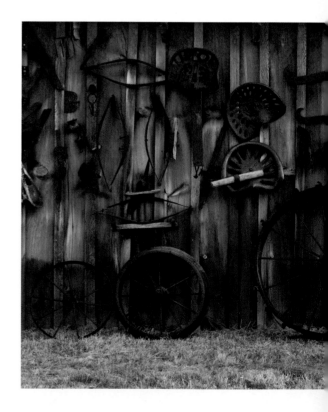

3. Look at the scene and evaluate it for exposure. If the scene has fairly even light all the way through from left to right, you can use automatic exposure. We tend to use manual exposure and set it to protect any bright areas of the scene.

4. Remove any polarizing filters, as they can affect the sky and other reflective elements.

5. Hold up your hand or finger and make an exposure that indicates the start of the series.

6. Swivel the camera from left to right and make the number of pictures you calculated you'd need earlier, overlapping each picture by about 50%.

7. When you're finished, hold up your hand and make a final picture to note the end of the series.

8. Load the series of pictures in your computer, then open up your favorite application for stitching and have some fun. If you're using Photoshop, select Photomerge, found under File > Automate. You'll get a dialogue box for choosing the pictures, and a choice of which method to use to combine the images. We typically use Perspective or Cylindrical. Whichever method you choose, you'll get a stitched-together picture that shows your neighborhood in a new way.

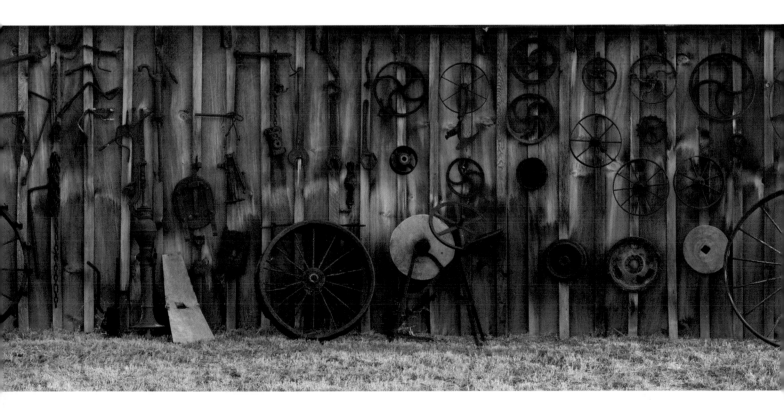

PAN FOR PHOTOGRAPHIC GOLD

right: To capture the energy of a bustling city, I decided to slow my shutter speed and pan vehicles as they passed. I was lucky in this image to capture both a taxi and a motorcyclist. I liked how they were both heading in slightly different angles, creating visual tension in the movement within the frame.

14–24mm lens at 19mm, f/7.1 for 1/6 sec.

below: This was a great wall for panning with motion as the colors blended well, but I needed someone to move through the scene. When this scooter came along, I tripped the shutter release and hoped I had timed it right to get him in a good spot. I like how the rider is ghosted, and the fact that he's in dark clothing adds mystery to the picture while the wild colors blur behind him.

25–105mm lens at 32mm, f/11 for 1/20 sec.

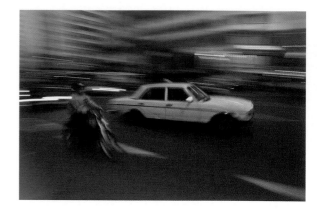

Panning is another way to create a different feel to a picture. Panning on a *moving* subject expresses the energy of motion while abstracting the background. Panning on a *still* subject abstracts the entire scene, making it more of an impression.

When panning on a moving subject, choose a fast shutter speed to keep the subject sharp while blurring the background, or slow your shutter speed down for a more abstract scene of a moving subject against a moving background. Try panning bicyclists, joggers, or dogs running after Frisbees in the park. Try your hand at panning as horses run in a farmer's field or at the racetrack. Capture the rush of someone running to catch a bus. Have fun changing your shutter speed and experimenting with fast versus slow pans. It's all about trying to show the world

around you in motion, and anything can work. Note that when panning moving subjects, it's usually more effective to pan horizontally rather than vertically, because most things moving past us are doing so in a horizontal direction.

You can also try panning on something that isn't moving at all, such as the trees in your local park, gardens in bloom, rolling hills, or sand dunes. Even buildings and

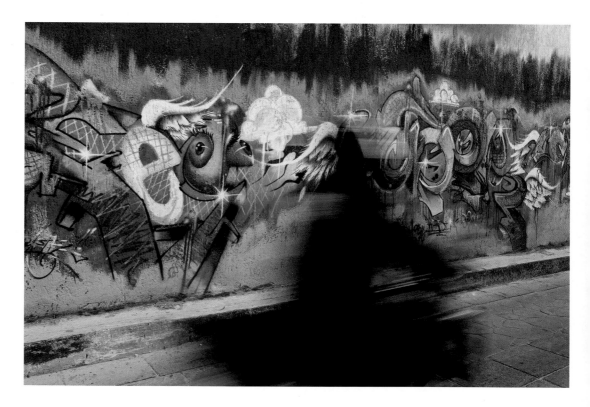

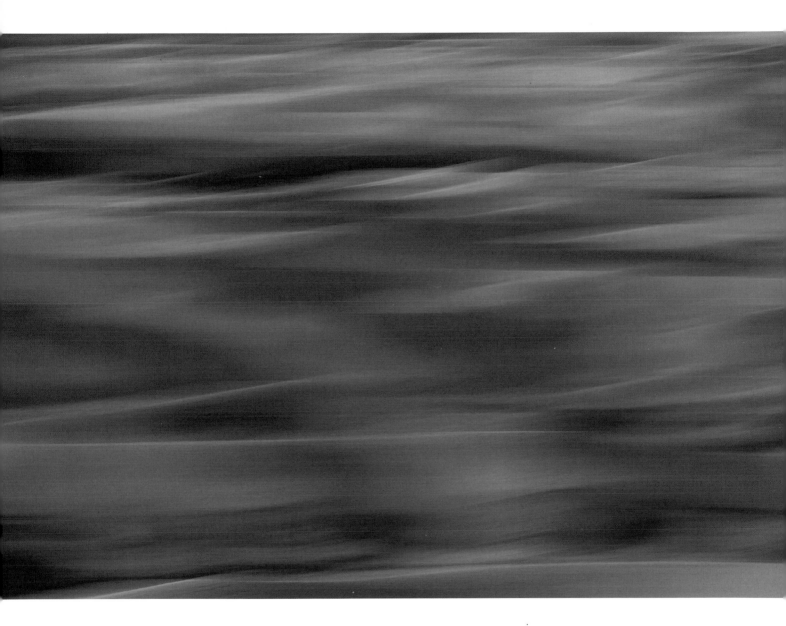

B The last rays of sunlight were grazing the surface of these hills in eastern Washington. I panned my handheld camera horizontally to blend the light and the colors of the fields. It's not your everyday view of agricultural fields—it's an interpreted vision, an expression of how looking at that landscape felt like looking at a painting.

*70–200mm lens at 185mm,
f/11 for 1/6 sec.*

J *this page:* While riding to the airport in the back of a car one beautiful morning, I was watching the dawn light through some trees as they blurred past and decided to play around with making photos. As the car was moving fast, my slow shutter speed recorded the blur yet still left beautiful impressions of trees, each completely different from the others. Play can have wonderful results.

24–85mm lens at 127mm, f/13 for 1/6 sec.

B *opposite top:* Panning upward on this stained-glass church window created a flowing feeling, and made it look a little like grasses, or reeds. It took about a dozen images before I got two that I liked.

24–105mm lens at 105mm, f/22 for 1/3 sec.

opposite bottom: Standing in a store, I noticed the rich warm wood floor and the cool blue light coming in from the large windows. The color contrast was great, but it was just a bunch of people standing around, and wasn't really a good picture. I decided to pan to blend the colors I saw and create something fun. Using my iPhone, I panned upward using a slow shutter camera app. You really can make artistic interpretations of everyday things anywhere.

iPhone, using Slow Shutter App

other structures downtown can work with this technique. We use this technique pretty regularly, often just to loosen up when we go out to make images. When panning on a still scene, it's best to pan vertically, perhaps because there are more vertical subjects, such as trees, tall buildings, boat masts, flower stalks, and so on. But there are always exceptions. Use a slow enough shutter speed to give you time to move the camera up or down in a sweeping arc, covering the entire area you want to include. Generally, between 1/8 and 1 second will give you enough time to move the camera, but it depends how quickly you move it and how much you want to include in the frame. You'll typically need a slower

shutter when using a wide-angle lens versus a telephoto lens as it takes more time to cover the same distance.

Watch out for dark or very bright sections in your scene, as they will still stand out even when blended with other tonal values near them. You can pan the camera one direction or both up *and* down during the same exposure. Trees in a forest can become ghostly with this technique. Play around with random motion; any type of movement will give unique results as you are "painting" with the light that falls across your sensor. When you get one that really works, it's exciting! There are so many different things you can try with a slow shutter speed.

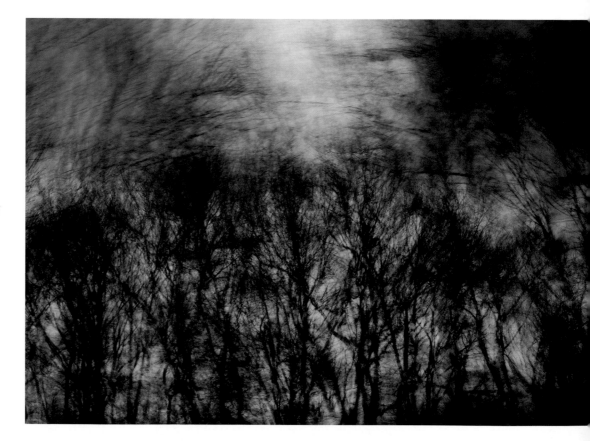

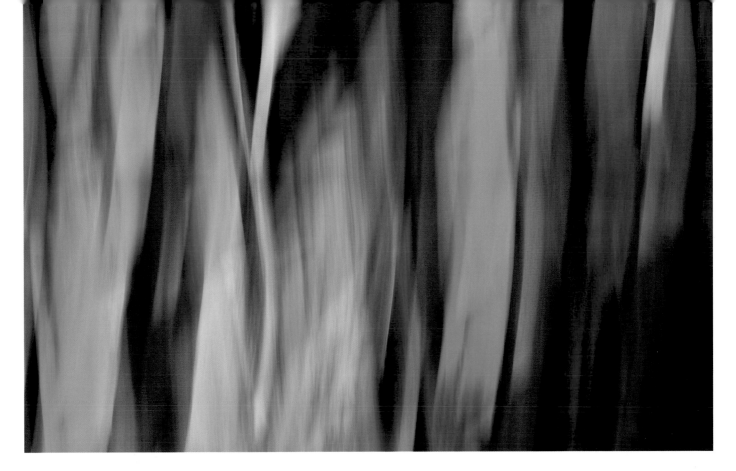

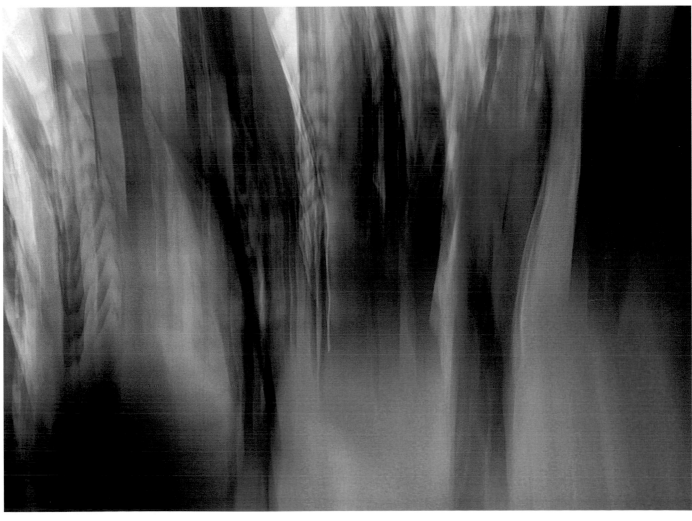

Using Artistic Filters in Software

B | When I photographed my neighbor's dahlia blossom, I was wistfully thinking about the old Polaroid SX-70 manipulations I used to do. By trying out different brush settings and so on within the dialogue box of Photoshop's Liquify tool, I was able to get the look I wanted. It just took time and patience, along with several clicks of the Undo button, to get it right!

Panasonic Lumix, f/8 for 1/60 sec.

When we want to take our images beyond photo-realism, we like to explore different software applications to create painterly effects. There are so many software options out there that allow you to do this, some of which offer presets to get you started in a particular direction. Our favorites are applications from Topaz Labs and Alien Skin, but it's a personal choice. Photoshop also has a set of artistic filters. You can create a stained-glass look, a rough pastel or watercolor effect, and more.

There is a tool under the Filters tab in Photoshop that Brenda has come to love: the Liquify tool. It offers a way to create a very painterly effect, similar to the older technique of manipulating the emulsion of Polaroid instant film while it's developing. When that film was discontinued, a friend recommended she try the Liquify tool; she was hooked! She now has a new way to create painterly images of any subject. There are other software programs that allow you to "paint," such as Corel Painter, but the Liquify tool and the artistic filter set are worth trying out first, if you own Photoshop. With some experimentation and time to perfect the results, you can create your own painterly look. There's more than one way to do it; you just have to play, which is part of the fun of learning how to use the tool. It's yet another fun method for making interpretive images.

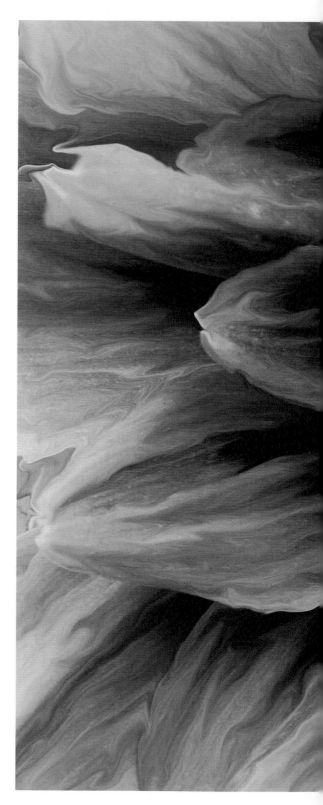

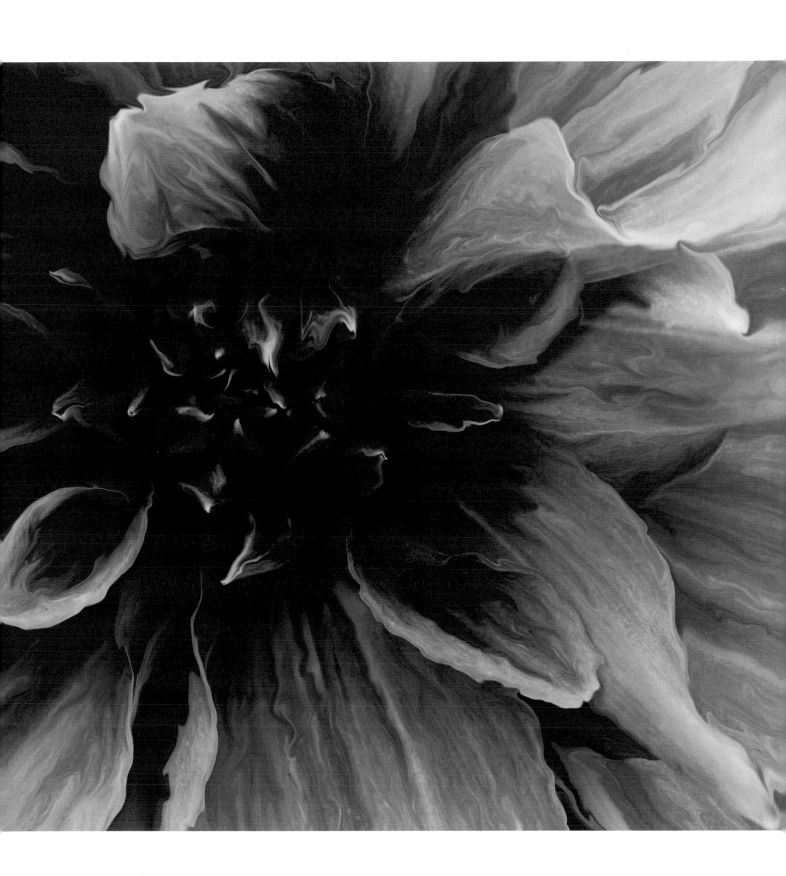

Seeing Double, Triple, and More: Multiple Exposures

J
opposite top: One day we went out to photograph wildflowers, but nature had other plans. It was raining off and on, and the wind was unrelenting. One of our trip participants was wearing the most amazing pair of boots, so rather than give up on photographing, I decided to have some fun. Since everything was moving around too much to get any sharp images, I decided to make a few multiple exposure images of her boots and the surrounding flowers. Luckily she had dark pants on or you wouldn't be able to tell where the boots ended and the flowers began.

All eight exposures (with Auto-gain on): 70–200mm lens at 105mm, f/2.8 for 1/640 sec.

B
opposite bottom: To create this staccato effect, I moved the camera vertically a tiny bit for each exposure and later combined the exposures in the computer using Photoshop.

All twelve exposures: 100mm macro lens, f/5.0 at 1/40 sec.

Multiple exposures are just plain fun, and a very creative way to express the world around you. Some cameras have a setting for a multiple exposure and combine the pictures for you; others require you to make all the pictures and take them into your computer to combine them. Either way, it's a great way to stretch your imagination. Painters in the Impressionist period created stippled effects like this. Are we as photographers trying to be painters? *Yes*, and why not? For us, painting and photography overlap. It's the *impression* that we want to express, and it's great that we can do so with a camera instead of a brush.

If your camera allows multiple exposures, simply set your camera on Auto-gain and it will automatically adjust the exposures based on the number you plan to make, as you go. Your camera might call it something else, so check the manual to see what to do for multiple exposures.

If you can't do multiple exposures in camera, here's how to make the pictures and then blend them on your computer. First, as you make the pictures, move very slightly for each picture, in a random fashion, or in one direction for a more staccato effect. Make each movement small or things won't overlap for that stippled effect. Then convert your raw images to TIFFs, making the same adjustments to all the pictures in the series.

Open each of the pictures in Photoshop. Choosing one as a base, stack the others on top of that one by dragging them over to that open file. (Command- or Alt-A to select the image, then hold the Shift key down as you drag it on top of the base layer so they align on top of each other.) Repeat for each image you are stacking.

Starting at the top of the stack, adjust the opacity of each layer using the following formula. Take the number of total (including background) layers and adjust the opacity of each layer to 1/x, where x is the layer number. So if you have eight layers, including the background, the top layer would get 1/8, or 12%, opacity. The next layer down would get 1/7, or 14%, opacity. The background should stay at 100%.

The process above is a good guideline to get the effect you see in the pictures in this chapter. But nothing says you can't do it your own way! Sometimes, for example, we leave out a layer or blur a layer to soften the effect.

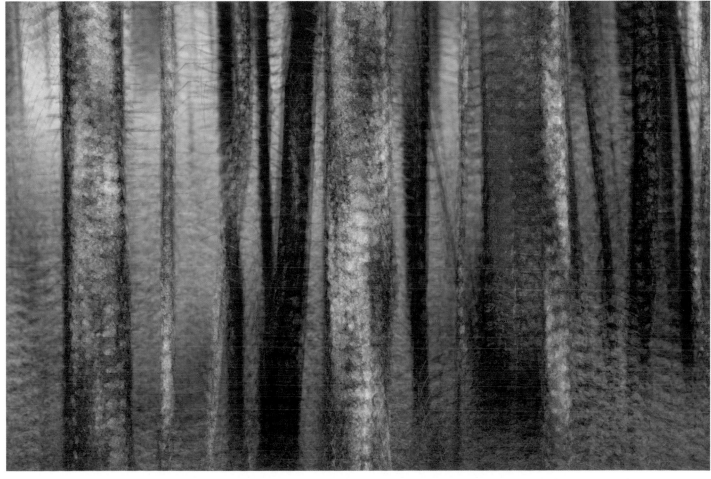

IT'S A LENS, BABY!

B | I was reading on a friend's porch and liked how summery the scene felt. I set my glasses down to add to the story. The Lensbaby lens seemed like a good choice to create a nostalgic, dreamlike feeling to the scene.

Lensbaby (50mm) Composer lens, f/2.8 at 1/80 sec.

If you want to really play, consider using a Lensbaby lens. The Lensbaby lens is a lens that mounts to several popular camera models and offers unusual effects, such as highly selective focus and shallow depth of field, dreamlike blurs, and lots of chromatic aberration. It's fresh and different, and it just might get you excited about photographing things near home again as you view the world around you through these lenses. Use one to photograph people, cars, buildings, or, with their macro kit, flowers (or any sort of macro subject). There's no limit to what you can choose for subject matter. Check out the Lensbaby website and you'll be inspired by the collection of images. If you have one, but haven't done much with it, now's the time to dust it off and spend time getting to know it. It really does take some time to get the hang of using it. If you are used to having total sharpness in your frame where you want or need it, it might take some real loosening up and letting go to see what might be possible. Lensbabies remind us of when we used to smear Vaseline on a filter to get a softer look, but it's so much better than that—and a lot less messy!

In a Dreamlike State: Montages

Montages are nothing new, but over the years a dreamy, soft effect was developed for montages that became very popular, and it's still a great way to create a different effect. By combining an in-focus picture with one that is out of focus, you get a diffused glow, or soft halo, around elements in the frame. There's sharpness and softness at the same time, which plays on the mind. This is not a technique that works for everything, like most special effects, but it's a great way to get out of your comfort zone!

Making montages is a lot like making multiple exposures (see page 62). If your camera makes multiple exposures, set it to do two and turn your Auto-gain on, and the camera will make the right exposure adjustment for blending two images. Otherwise, you'll need to make two images in the camera first. Here's how to do it:

1. First, make two exposures in the camera. Make the first one sharply focused, somewhere around f/11 or f/16—enough to render sharp everything that you want in focus. Then make the second exposure using the widest aperture setting on your lens, say f/2.8 or f/4, and defocus the lens so that the image blurs but gets larger. You want to defocus by focusing closer, not farther away, in this case. Note that zoom lenses in the range of 17–135mm typically won't defocus larger by the way they are designed, but 70–200 or 70–300mm lenses will, as will lenses with a fixed focal length. This will take some experimenting, so make a few exposures with differing amounts of blur.

2. Convert your raw files to TIFFs, then open your two image files in Photoshop.

3. Select the blurred image (Command- or Alt-A), then hold the Shift key while you drag it over the sharp image.

4. Choose your blending option and adjust opacity to taste. This is where it's very subjective. There are quite a few choices, so we recommend trying them all. We tend to prefer Overlay or Multiply, but there is no one answer, so experiment.

J I saw these plants in a botanical garden and was attracted by how soft they looked and by the backlighting. To enhance this effect, I made a double exposure in the camera using Auto-gain, but I changed the aperture and the focus between the two exposures. One image is sharp with good depth of field, while the second image is out of focus with a wide-open aperture.

First exposure: 105mm lens, f/16 for 1/15 sec.; second exposure: 105mm lens, f/3.2 for 1/400 sec.

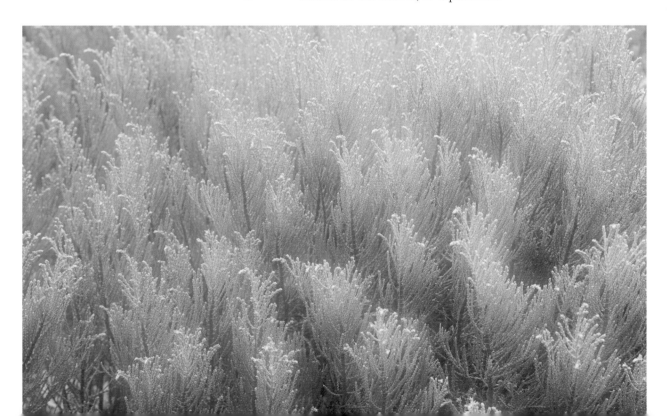

DIPTYCHS AND TRIPTYCHS

I made this picture without thinking of making it a triptych, but later after seeing a few similar compilations I decided it would be a good candidate. At the distance this printed piece is normally viewed, the lines between the segments are skipped over by the brain and the picture reads as a whole scene.

Original single image: 70–200mm lens at 185mm, f/16 for ½ sec.

Diptychs (two images grouped together), triptychs (three images grouped together), and variations thereof can be wonderful ways to present a photographic theme or study of something. You can choose one picture and divide it up into the number of picture sections you want, print them, and mat them with a little space between them. It's really that simple, but the effect has strong impact.

Even more fun is planning for a series that you'll combine in one mat. Choose subjects that are similar in theme or color—for example, four studies of the same tree in all four seasons, three or four different flowing water images, or flower blossom close-ups. Just about anything can work, and some that aren't related can, too. Going out to photograph with a diptych or triptych in mind can help you see things that may relate to each other well, or play off each other in some unusual way. You can also use just one existing image and print three sections of it, spacing them out on the mat. The space you put between the three sections takes a little figuring out; your framer can help as it depends on the distance from which people will be viewing the framed picture. The idea is that when you stand back far enough, the eye blends the pieces together and the story becomes complete.

USING YOUR PHONE

We hesitated about putting this section in the book, concerned that we might never be taken as serious photographers again. But then we realized we don't *want* to be serious all the time! Photography is about exploring how we see the world around us, and for us as artists, using the phone is just part of the visual growth process. Judging by the books and DVDs on this topic and the number of social network groups dedicated to it, we're not alone. The main thing is, it's just plain fun, and the creative stretching has us not only seeing differently but also thinking about ways we can postprocess our other images. We have to get used to working in a four-thirds format and we have to zoom with our feet, because the lens is really wide. We still have to watch our light and our composition, and we choose apps that allow us creative control, like focus and exposure adjustments. Our phone cameras have been great ways to document things around town because they are always with us.

B I made one picture of this tree and then took a texture file from a folder I keep in my phone library and applied it over the scene, blending the two together using apps and controlling the outcome. That's where the art comes in, when you make the adjustments yourself using the sliders within the apps instead of using instant-effect apps—although they can be fun, too.

iPhone, two image files blended using the app IRIS

DELIBERATE BLUR

I made this photograph while playing with our dog on the beach. It's surprising how well it actually worked. It took a few tries to get just the right amount of defocus, but the result is a suggestion of beachcombing, in a dreamy, painterly style.

Canon G9, f/6.3 for 1/500 sec.

Dare we suggest you deliberately photograph *out of focus*? We dare! We once saw an exhibit in New York City where the pictures were all large, out-of-focus prints, each selling for several thousand dollars. The strange thing was that they still worked. As we stood back and looked at them, we understood what each image was about. We could hear the cash register "ka-chinging" as we imagined doing this ourselves. But it's not as easy as it looks. If it's not out of focus enough, the brain simply says, "Hey, you missed the focus, stupid!" But if it's too out of focus, the picture becomes a mess of indefinable elements. There's a point at which a lack of focus becomes just a study in form and shape and the brain accepts that instead of trying to make it sharp. Blur is not a technique we use every day, but it sure did pique our interest, and in the process we learned that it's also a compositional tool, to see where the visual weight lies in the frame.

TEXTURE OVERLAYS

Textures overlaid on an otherwise "straight" photograph can make a picture feel old or gritty, or simply add some dimension. Try doing texture overlays in Photoshop or using an iPhone app, adding a texture from a collection of texture files you can purchase. You can also create your own texture files. Look for stucco and weathered walls, wood fences, rough sidewalks, and sand to help you build a collection of textures.

Here's how to add a texture overlay in Photoshop:

1. Open your image as well as the texture you plan to overlay.

2. Select the texture file (Command-A/ Alt-A) and drag it over the main image while holding down the Shift key to have it land perfectly aligned.

3. Now comes the fun! Play with the blending options—Multiply, Darken, Overlay, Soft Light, and so on—to see what effect you like the best. We use Overlay and Multiply quite a bit, with opacity adjustments to taste. But it's entirely subjective, and there are many ways to make this technique your own.

B I took this image of trees one clear autumn day just because I liked their contrast against the deep blue sky. But something more was needed, and I knew at the time that I would try to overlay a texture on the picture. I used a texture that made it look like it was snowing, an effect I liked.

24–105mm lens at 45mm, f/13 for 1/80 sec.

Toning Black-and-White Images

B These robes were interesting enough in the original photograph, with the way the side light brought out their form. The color of the room, however, was blah, so I converted the picture to black and white—but then it felt cold to me. After I added a sepia tone using Nik's Silver Efex Pro, I liked it much better.

70–40mm lens at 33mm, f/7.1 for 1/40 sec.

If you want to create a richer effect than simply converting your pictures to black and white (see page 52), consider adding some color toning to your converted images. Darkroom photographers frequently do this to their monochromatic pictures. You can add cool or warm tones or sepia tones, or combine tones for a special look. Nik's Silver Efex Pro is a terrific software application for creating toning, both with the adjustable presets included and with the option to select just a certain area to work on. Adobe's Lightroom can also be used, with its adjustable presets. Photoshop also works, although it's a bit more complicated and involves using layers and masks. To keep it fun and simple, we recommend programs that have adjustable presets for creating your own personal look.

DRAWING ON YOUR PHOTOGRAPHS

Jed has developed a style he calls *Lightlines*, in which he draws on photographs with a fine-point technical ink pen. He developed this technique while studying cartography and aerial photography in college, where tonal variations in vegetation, geology, temperature, and so on are often delineated in photos for creating maps. He started drawing on his own images, looking at each photo only in terms of variations between areas of light and dark, rather than what the subject is, and he has since pursued it as a creative pastime with commercial results.

It's not a technique that is easy to teach, as there's no one method of doing this, but the effect is interesting and produces one-of-a-kind results!

Using the above in-camera methods and software programs is a wonderful way to express an alternative vision if you want to take a picture beyond photo-realism. It's a way of stretching artistically, and even if you decide to stick to a truer rendition of your scene or subject, the process can open you up to new ways to see "straight," too.

J This picture of deck chairs was a good subject to draw on later, because the areas of light and shadow have distinct tonal variations, making it easier to apply this technique. I often make a picture with the idea of drawing it on it later. I look for a scene that has areas of light and dark that I can separate visually with my pen to create the graphic effect I want, as sometimes a lighter exposure works better, or a composition with a lot of details. It's a very subjective technique, but fun to try!

Original on print film, data unrecorded. Scan of altered print.

Capturing Everyday Moments

LIFE IS FULL OF moments. Some make us happy, joyful; others make us sad, heartbroken. Either way, these moments touch our lives and are worth recording. Whether you have paid attention to them or not, there are thousands of moments happening around you in your everyday life, right where you live: a woman hails a taxi; a kayaker paddles on a river; joggers, cyclists, skateboarders are on the move; a dog shakes off water; a man practices tai chi in a park. The list goes on and on because we live in a world of constant motion, where moments of all kinds happen every minute.

How often do you notice things for the wonderful moments they are? It's easy to see moments when we're traveling, perhaps because it's a new place and we're seeing it with fresh eyes. But many of the activities we see when we travel are the same ones that happen in our own home area. So why are local moments less interesting? They shouldn't be. There are many common moments in your own area that are worth capturing: people shopping at an outdoor market, playing sports, running with their dog, exploring tidal pools with their children, hanging out with friends at outdoor cafés. Take a good look at what's going on around you. You just might find yourself reinvigorated photographically.

B This father was cradling his very young infant at a parade. I loved the protective gesture and how the size of the man's hand gave you a sense of how small this child was. The light bouncing off the sidewalk gave a warm glow to the baby's skin, which was in shade. I approached the father quickly, saying, "Please don't move a muscle. I love the way you're holding the baby." If I had just walked up and started photographing, he might have shifted or backed up, thinking he was in my way, and the moment would have been lost forever.

24–70mm lens at 45mm, f/8 for 1/125 sec.

BECOME A LIFE WATCHER

B

I love winter and love to shovel snow! Crazy, maybe, but this picture spoke to me about New England winters and about walking down long driveways in the country. I timed it to get the man's foot in the air as it is a gesture that expresses the act of walking. The trailing footprints serve as a leading line to take you into the scene.

70–200mm lens at 121mm, f/11 for 1/320 sec.

Photojournalists are trained to tell stories with their pictures. They look for body language, gestures, and expressions that tell the viewer what's going on, that express the humor, irony, tension, or anger of a situation. It's those moments that make a story come alive. That's what you need to watch for also, but you genuinely have to be interested in people—and the human condition—to be willing to pay attention and anticipate the incredible moments that occur. This is half the fun. We are a race of unique, animated personalities, and the gestures we make and the actions we take are downright priceless. If you're caught up in your own world when you go out the

door, you'll miss many good photo opportunities. Get outside of yourself, become a life watcher, and celebrate the moments that make life the precious experience it is.

Learn to watch people without their knowing they're being watched. In Alaska, bears watch each other with what a naturalist friend calls "studied indifference." They are looking at each other, but pretending not to be looking by *casually* looking as they scan the scene. It's true—we've seen it happening! And we learned that if we do that, too, the bears are less concerned about us. We've applied this idea to people and scenes with people in them—scanning, casually taking in the scene in front of us but not staring at it, observing it all, ready to make the picture when the moment occurs. Also, by staying loose while observing, you are more likely to see something happening in the periphery that might be just as wonderful. Go to an outdoor market and stand for a while, just watching people go about their business, before you even get out your camera. Watch for patterns in how they move or any repetitive behavior, for example, the fruit seller who offers a slice of something to interested shoppers. The moment he leans out with knife and fruit, there's your image.

You already see more moments than you may realize—but you have to become conscious of them to be able to photograph them. The more you study people, especially those you know, the more you'll notice that thing they do with their hands, a certain look or expression they have, or how they move before they let out a great laugh. And then you'll be able to anticipate what

gesture or action might come next. By studying animal behavior, we have been able to anticipate when they might run, or fly. For example, you can tell when horses are thinking about running as they get fidgety, shifting from foot to foot. When an owl is about to fly from its perch, it often poops just before it takes off! We're sure you're laughing now, but it's true, and it's helpful information if you want to capture the bird in flight. Not all behavior is predictable, certainly, but when you learn to recognize certain actions, you can anticipate what will likely come next and be better prepared.

To be ready for almost anything, you'll want to have your exposure figured out, the appropriate shutter speed and aperture chosen, and maybe even your focus set— although any one of these things could change if the light changes or the subject moves. If you have enough light, you can preset an aperture that will give you enough depth of field so you don't have to refocus, unless the subject moves outside that zone. Make sure your shutter speed is fast enough for any action that might occur in the situation. On the other hand, motion may be part of what you want to express—for example, two people loading or unloading a truck, or someone riding by on a bicycle. The shutter speed you choose depends on what sort of moment you think is about to happen.

Photographer Henri Cartier-Bresson felt that "thinking should be done before and after, but never while actually making the photograph." For his photojournalistic style of photography, this was true. If he'd spent too much time fussing with his settings, that infamous man jumping over the puddle would have been long gone. You need to react in the moment.

J I'm not sure what they were doing, but I loved the moment of these two sharing some discovery and the sense of connection that was there. The child's body language expresses how focused she was, and Dad's gesture suggests they were finding neat things on the ground. The backlight rimmed them both so nicely, and the simple background gave it an urban sense of place. By using a telephoto lens, I was able to capture the moment without interrupting their fun.

70–200mm lens at 120mm, f/4.5 for 1/800 sec.

WHERE TO FIND THE MOMENTS

this page: This is a favorite moment of mine because of the icons: the American flag and ice cream! One of the boys even has a flag on his shirt. It was a patriotic parade day in our hometown and a great place to photograph moments like this. These boys were so busy watching the parade, they didn't even notice me photographing them. It turned out they were our neighbors! It's good to get out and meet people as you never know who might be a good subject.

24–70mm lens at 40mm, f/7.1 for 1/160 sec.

opposite: We just happened to be walking by this artist painting a mural and loved the colors and the whole juxtaposition of him against the animal figures. When he stretched his hand out, that was the moment for me that expressed the act of painting. Notice even how he's holding the brush.

Canon 10D, 100–400mm lens at 105mm, f/4.5 for 1/160 sec.

Anywhere life is being lived, you'll find moments involving people. Maybe you're not usually a people photographer, but the skill of anticipating and capturing a moment with people can be transferred to photographing wildlife and birds. If you're used to photographing active children, you might already have the skills for photographing wildlife and sports!

Here are some great places that are full of moments to capture:

- **Farmers' markets.** Markets are hubs of activity and wonderful places to photograph interactions between people. There are moments when produce is weighed and money is exchanged, when hands gently squeeze fruit, or when the farmer hauls an armful of fresh produce to the table. Getting to a market early gives you a chance to scope out the scene and get ideas, and to photograph vendors setting up their displays. By the time the crowd arrives, you've potentially gained a certain amount of invisibility, too, as you've become part of the scene, and that's when you can get the best candid moments.

- **Festivals.** Festivals bring out the celebratory spirit in all of us. Renaissance fairs, arts or music festivals, carnivals—events like these provide incredible opportunities to photograph the gestures and moments of a variety of people, from the performers to the audience. People are outwardly focused at festivals—looking, participating, engaging. And at some festivals, closet performers show up, dressed to be on display. They're also great places for portraits and details.

- **The street.** Street photography provides an opportunity to capture a slice of everyday life that often goes unnoticed. There is the lonely street sweeper cleaning up after a busy party night, deliveries being made at shops, a man exercising his dog, an old woman feeding the birds, or men and women practicing tai chi in the park. It's hard to describe what the photographs might be, yet the potential for interesting moments is high when people are involved. A lot of things are happening in small towns and large cities in the early hours of the day. If you live near or in an urban environment or busy town, you have opportunities to capture these moments and more. If you live in the country, there are farmers guiding their cows into pasture and people working in fields. In small towns, there are diners, cafés, and general street scenes of locals interacting. All you have to do is get out there and explore.

There are also moments that do not necessarily involve humans or animals. These are the moments when nature gestures, in the form of light breaking through the clouds in a perfect way, a shaft of light illuminating a boat in the harbor, or a rainbow arcing over the highway.

Asking Permission

When photographing candid moments, it's okay not to ask permission—if you do, you usually lose the natural moment you saw. You need to get that moment first, and if you are noticed, smile, gesture with your camera, and gauge whether it's okay to continue by their reaction. Making a candid photo is simply observing and recording life's moments. It's not being sneaky in a negative sense. But when getting in close, you may want to ask permission. You can then ask them to continue doing whatever it is they were doing to get back a candid feeling, if you wish.

BEING PREPARED

Great moments can be captured on any camera—but they won't be memorialized at all if you don't have one with you. So don't leave home without a camera in your pocket or purse, or around your neck, if you want to seize the moments that you see.

With a compact digital camera, one of the most frustrating things can be the timing lag between pressing the shutter button and having the camera focus. To get around that, you can press the button partially down so the camera focuses and hold it until the moment you want to capture happens. It's not always easy, as you don't know what the moment will be or when it will happen, but in the case of photographing your kids or family, or a predictable action, like a pitcher about to pitch a ball, a golfer about to swing, and so on, you can be ready with the button held down. For more unpredictable situations, you just have to get good at recognizing when a moment may unfold. We call it *anticipating the anticipation of the moment*, because you have to think something might happen and be ready for it, even though you don't know if it will actually happen!

DSLRs don't have that shutter lag issue, but you can still prefocus and hold the shutter button down to lock focus until the moment occurs, to be better prepared. However, metering will be set to whatever the light reading was when you pressed the button partway, which could be a problem if the light changed while you were waiting for the moment to unfold. We prefer to have our shutter button do the metering and the shutter release simultaneously, and have a back button on our camera do the focusing (see tip box, page 79).

J Sometimes a moment can be totally unexpected, which was the case with this owl. We had spent the morning photographing and were on our way down the road when we came across this owl sitting on a PRIMITIVE ROAD sign. All eight of us got out of our cars very quietly and started to photograph. Our first images were from about 50 feet away, but since he seemed unfazed by our presence, we slowly moved closer. Eventually, we were close enough to get this framing. For most of the time he just sat with his eyes half closed, but suddenly he opened them up, flicked his ears, and stared straight at me—and I got this moment of piercing connection.

200–400mm lens at an effective 510mm, f/6.3 for 1/250 sec.

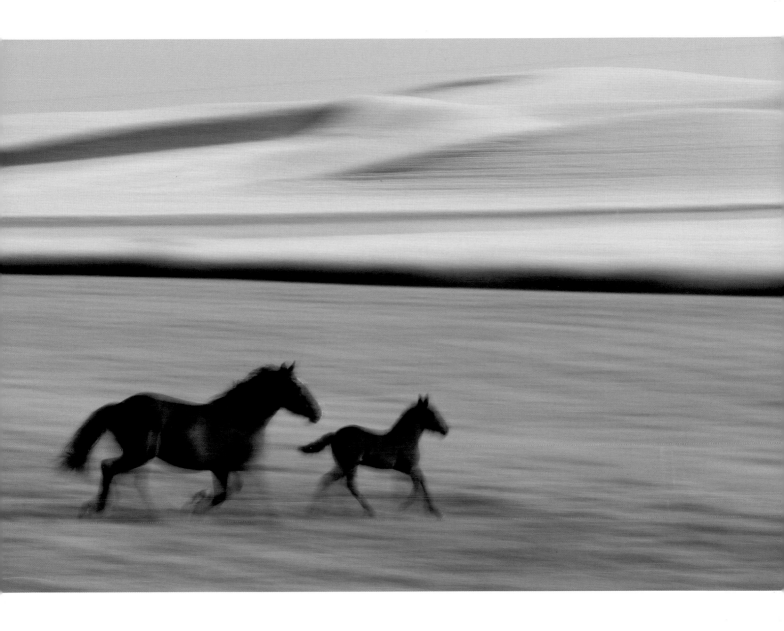

Separate the Focus and Metering

Most cameras have the shutter button doing metering, focus, and shutter release by default. But several models allow you to separate these functions. You'll need to read your manual to see how to set it up, if you can, with your camera. It took a while to get used to this setup, but now we can prefocus using that button, and when we see the moment happening, press the shutter and get an exposure at the same instant the picture's made. Not everyone likes this method, but we love it after getting used to it.

B I was walking down the road when suddenly someone from our group called out, "The horses are running!" I quickly turned and tried to capture it but had the self-timer and mirror lock-up on. Thankfully, the horses continued to run and I managed to get a few images. I chose to pan using a slow shutter speed because it just made sense to go with their flow.

70–200mm lens at 89mm, f/16 for 1/6 sec.

PRESET YOUR CAMERA

Set your camera to an aperture that gives you a good working depth of field. For example, using hyperfocal distance charts as a guide, we determined that when using a 35mm focal length and focusing on something 15 feet away, an aperture of f/8 would give you sharpness from about 8.5 feet to 127 feet. If your main subjects are within that range, they will be sharp. This means you can raise your camera to your eye, compose, and snap without refocusing the lens. If you can't separate the focus from the shutter release (see tip box, page 79), then switch to manual focus and you won't have to worry about the camera refocusing on you.

Depth of field and hyperfocal charts are available online and as apps for your smartphone, making it easier to predetermine your settings to get the depth of field you want. Learn just a few of the settings and it will be easier to photograph quickly. This is how many photojournalists traditionally used their rangefinder cameras.

Ever wondered how men in bulky space suits focused those cameras on the moon? They were prefocused using this technique. All they had to do was make sure their subject was beyond the minimum focused distance. Note that compact digital cameras have a much greater depth of field at the same aperture settings as DSLRs, due to a smaller sensor, so even at apertures of f/3.5 and f/4, more is in focus, so you may not need to worry much about the depth of field.

opposite: Here's our favorite pup swimming in the ocean, or, rather, retrieving. She was so proud that she had gotten the toy, and when she turned and looked at me, I got this special moment. I used my telephoto lens to frame her tightly and a fast shutter speed to freeze her motion and the splashing waves around her.

70–200mm lens at an effective 300mm, f/6.3 for 1/800 sec.

below: While photographing in San Francisco's Chinatown, I noticed this energetic exchange between the older man and the newspaper vendor. I liked how their expressions told a story about their lively conversation.

70–200mm lens at 200mm, f/2.8 for 1/320 sec.

NOTE: You can certainly use your camera to do these exercises, but it's a good idea to practice seeing without the camera, as you can see more than through the viewfinder. It will help you see what leads up to the moment.

EXERCISE #1: A WALK DOWNTOWN

To develop your observation skills, take a walk downtown on a busy street and observe the actions of people around you. Don't try to photograph at first, just observe and try to predict what gestures will come next, say two people talking or someone playing with a dog. Make it a game to see how closely you can anticipate what comes next. Focus your attention on really looking at activities around you and figuring out how to anticipate moments. When you're ready, bring your camera and practice getting your timing right for the peak of an action or gesture.

EXERCISE #2: VISIT THE BEACH OR A PARK

These are great places to watch people interact with each other or their pets. Do the same thing as in Exercise #1: Leave the camera in the car and just observe the kinds of things that happen. Play a little game by saying "click" when you see a moment happen, say, the moment someone leaps into the air to spike a volleyball or jumps a wave. Evaluate how your anticipation or timing worked. When you think you're getting the hang of it, bring out your camera and start capturing moments.

B

left: I found this sea star on a kelp-covered rock and the gesture of its outstretched arms was just too terrific to pass up. I carefully lifted it and placed it on the sand. Just then, a wave came in and I almost lost my subject! But I acted quickly, making the exposure just as the wave came close. The result is a moment that feels like the sea star is sprinting away from the wave in a catch-me-if-you-can gesture.

24–105mm lens at 92mm, f/11 for 1/20 sec.

opposite: Prepared with his pail and wonderful boots, this young boy could go anywhere—and he did. I followed him all around, photographing a moment here, a moment there. Each of these pictures is a strong moment on its own, and together they tell a story of a child's curiosity on the beach.

70–200mm lens at 200mm, various exposures.

Finding Your
Point of View

Now that you're seeing all sorts of good things to photograph, it's time to think about how to make the most effective photograph possible of what you see. The first and most important question to ask yourself is this: What attracts you the most to what you are viewing? Is it the texture, the light, the colors, the shapes? Whatever it is, *that's* what you want to emphasize when making your picture. Getting in touch with what initially attracted you clarifies your vision, helping you choose the right point of view and composition to express it. If it's the repetitive pattern of archways in a downtown courtyard, you might choose a telephoto lens to visually stack the arches. If it's the light pouring through flower petals, try a macro or telephoto lens. You might have to lie down to get the right point of view for that flower, too.

B After many photographs of this tree, I surprised myself by finding a new view. Getting below the rock and using a wide angle, I emphasized the cracks in the rocks, which serve as a visual pathway to the tree. It was luck that brought clouds into view at just the right time.

24–105mm lens at 28mm, f/16 for 1/15 sec.

CHOOSING A POINT OF VIEW

J | By getting down on my belly, I was able to photograph this beetle coming right at me. It also allowed me to keep the background simple. I kept my aperture wide open so the background would be out of focus, drawing the eye right to him. You can see just a hint of his tracks going off into the distance, giving the picture some depth and leaving you wondering how far he had traveled.

70–200mm lens at 200mm, f/2.8 for 1/640 sec.

Choosing the best point of view is a great way to get exercise, as you have to climb up or bend down, lean, move to the left or right, or squat, all in the interest of finding the position that makes your subject look the best. We see a lot of photographers pointing their lens at the subject, or setting up their tripods, at standing height. What if there's a better position? If you haven't explored the possibilities, you're limiting your results.

Explore your subject from different positions before deciding on the final position. Think about your scene and analyze whether a higher or lower position might be better. If you want to show the expanse of a field of flowers, for example, a viewpoint from even slightly above will generally do that better than one from below. If you want to show how tall an oak tree stands, try getting down low and angling the camera upward. Getting closer to the tree will also enhance the feeling of height. If the background of a scene is very

busy, getting up higher so you are looking down on it can simplify the composition. You don't need to climb mountains—even a difference of a few feet can make a huge impact on your image, depending on the focal length you're using. Look around for stairs, a bench, or a rock you can stand on that will still give you a good composition.

Getting lower creates an equally interesting point of view. Remember when you were a kid, crawling around on the lawn? Those things were a lot closer to your eye than they are now, as you stand looking down at the meadow. Many nature documentaries put us in the heart of the action by getting low to the ground when filming. What does your street look like from the height of an infant or a dog? Get down on your knees or tummy and start looking around. No, it's not as easy as it was when you were a kid; we carry kneepads or a gardener's cushion to make this more comfortable, so we can stay down there long enough to make a good photograph.

Stepping It Up

We carry a small stepstool with us in our cars, and sometimes a larger ladder if we know that we'll need it. We've used them to get a higher viewpoint but also to get over hedges and low walls that sometimes block a great view. We used one to photograph a street painting festival, to see more of the art the artist was creating. We've used the top of our old VW van as a platform. You can rig a sturdy platform on the roof rack of your car if you want to elevate yourself to new heights.

B | I wanted a simplified scene of this tannery worker as he inspected the hides drying in the sun. Being above him on a porch allowed me to isolate him against the pattern of the hides. The sun was just low enough to still create an offset shadow of him, adding interest and dimension.

17–40mm lens at 64mm (with crop factor), f/16 for 1/250 sec.

B I knew this train was scheduled to come into the station, so I positioned myself at the railroad crossing to capture the cars as they went by. But the background was busy and I was worried that it might show through the windows of the cars too much. I knelt down, hoping to eliminate some of the clutter; in the process, I saw that the sign would fill in the solid space of blue sky nicely. I chose a shutter speed to give motion to the cars as they went through the crossing.

24–105mm lens at 32mm, f/10 for 1/6 sec.

Many years ago, Jed worked in a photo lab, and one set of wedding photos they printed fascinated everyone because they were so unusual. One picture was a low angle, looking up at a circle of people while they stood around talking, wineglasses in hand. They looked like giant redwood trees. Another was a low angle of a group of people on a couch, but their knees in the foreground of the frame looked like giant boulders with the people seated behind them. It turned out the pictures were made by a four-year-old who had gotten hold of someone's camera. (Thank goodness for autofocus!) These were some of the most requested images from the wedding, no doubt because of the unusual and funny point of view.

Think creatively, and don't be limited, if you can help it, in finding ways to get a new point of view of what is around you. Be willing to stretch, bend, and move to find the best position.

Exploring without Your Tripod

Don't keep the camera mounted to a tripod while looking for your point of view. If you're dragging the whole rig around, it's just not as easy to be creative in finding the best position. Move around and explore with just your camera, then when you've found the position you want, mark the spot with something and get your tripod. It may not seem like a big deal, but it can make a difference in how far you'll push yourself to get a dynamic viewpoint. And that position—whether standing or kneeling, looking up at or down on your subject—can make a huge difference in the impact of the picture.

CREATING VISUAL DEPTH

J This rock appeared to float in the shallow waters of a tidal pool along the coast. By taking a standing-height viewpoint and angling the camera downward, I could include the space behind it, separating it from the others. If I had gotten lower, it would have merged visually with the other rocks and weakened the picture.

70–200mm lens at 105mm (crop factor), f/16 for 1/50 sec.

We live in a world of form and depth, a three-dimensional world. Yet our pictures are two-dimensional, a flat representation of what we photographed. Your position or point of view can help you create the suggestion of depth in your picture. This effect is called *parallax*, and it's why having two eyes gives us depth perception. As you move around a scene, objects shift position in the viewfinder, moving in front of or behind each other, growing larger or smaller as you move in or out, higher or lower as you move up or down. By getting above something in the scene, you visually (though not physically) create more space between it and other elements (objects). You're not changing the space that is there, but by changing position, you can emphasize that space, and that creates a feeling of dimension in the final picture.

B *opposite top:* In the redwoods north of where we live, I got close to the base of this giant tree to show its detail and size, but used a wide angle to incorporate the background forest. This near/far relationship suggests depth by making the things behind your close-up subject appear farther away than they really are.

24–70mm lens at 24mm, three exposures combined for HDR image

opposite bottom: This wonderful fence provided a great subject for a sunrise along a country road. By getting close to the fence, I put the viewer there with me and created a feeling of depth in the scene with a near/far relationship of elements.

24–105mm lens at 55mm, f/16 at 6/10 sec.

Choosing an Angle of View

this page: Using a wide-angle lens, I got very close to this bench as a way to visually direct you into the street scene. It's extreme, yet different and fun. You can use this same approach anywhere there's a bench or even a low wall leading into the scene.

17–40mm lens at 17mm, f/16 for 6 seconds

opposite: Crouching down a little, I was able to fill the foreground with this crop about to be harvested, putting the harvester at the top of the frame. The angle of view and my position were chosen to make you feel like you are at the edge of the field, which is right where I was.

17–40mm lens at 29mm, f/16 for 1/40 sec.

Along with your point of view, you need to think about the angle of view, also called *field of view*, or how wide or narrow the scene in your photograph is as captured by your focal length. The normal angle of view for the human eye is about 46mm, so anything in the 45–55mm range appears normal and "comfortable" when we look through the lens at that focal length. But photographs made with that angle of view can be static because that's how we see things all the time. When using a lens in this range, think about point of view and choose a position that makes your subject or scene more dynamic and interesting. When it comes to finding the best framing for your subject, there's nothing less exciting

than a standing-height composition made using a 50mm focal length, unless the point of view is effective. However, we're all for making the most of "normal" focal lengths; Henri Cartier-Bresson once said he hadn't exhausted all the possibilities of his 50mm lens after years of working with it! Just think about your point of view and perspective carefully, and any focal length can create a great picture.

Depending on how you use different focal lengths, you can emphasize objects within your scene, or de-emphasize them. A wide-angle lens expands space, making things seem farther away. To gain back the feeling of being "right there," get closer to some foreground object, which

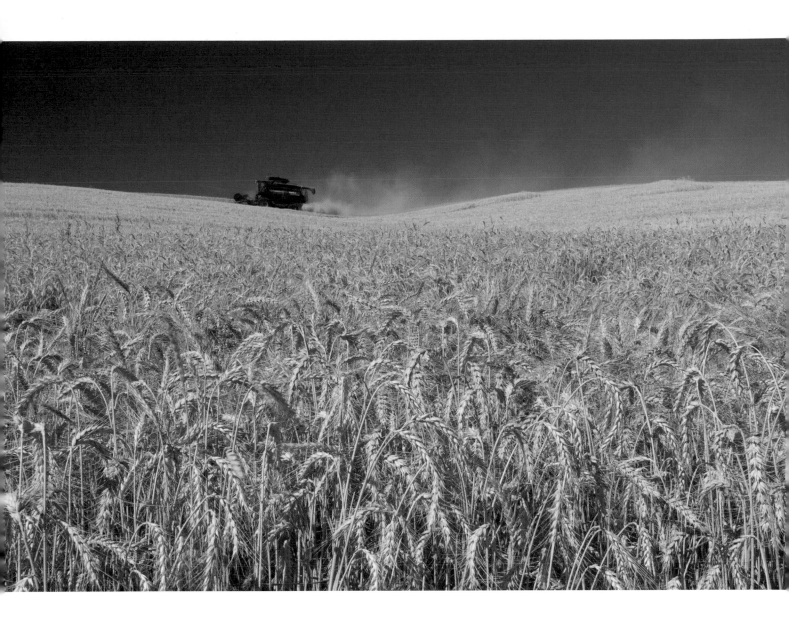

Make the Foreground Interesting

When creating a wide-angle landscape or scenic photograph, try to include something interesting—a lichen-covered rock, a grouping of flowers, a bridge railing—in the foreground. But remember that the fore-ground is not the whole story. You'll still want to have an interesting middle ground and background to make the final picture successful—otherwise, where does the viewer go once you've pulled him into the scene?

There are so many wonderful pictures to be made in farmland. The patchwork quilt was amazing in this section of farm fields during harvest. I used my super-telephoto lens on a crop-factor camera to compress the scene and emphasize the graphic shapes.

200–400mm lens at 465mm (crop factor), f/16 for 1/125 sec.

puts more emphasis on it and makes it a visual stepping-stone into your scene. You can achieve wonderful, high-impact perspectives with a wide-angle lens; you can even take this idea to the extreme with super-wide-angle lenses, really distorting the foreground for an unusual look. It's all a matter of how you want to interpret what you see.

While a wide-angle lens can expand a scene, a telephoto lens does the opposite, flattening a scene by optically compressing the space and sometimes visually stacking elements. The ups and downs of a country road can look a lot bumpier through a telephoto lens, and the trees that line that road will look stacked up next to each other as though there were only a foot of space between them, when there might really be 20 feet between them. This stacking can add strong impact to a picture. We also often use our telephoto lenses to extract a detail from a larger scene, or to make close-ups of things we can't get close to easily. A telephoto can also make something stand out from a busy background, if the subject is relatively close to the camera, due to its shallower depth of field at closer distances.

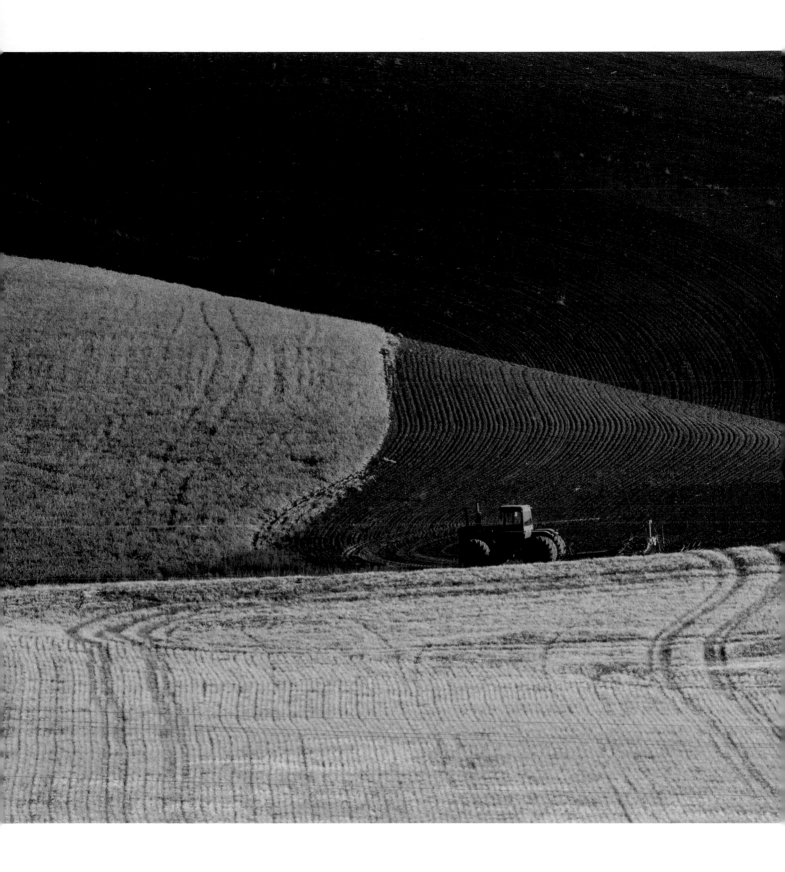

EXERCISE #1: LEARNING WHAT YOUR LENS SEES

You can learn to see the way a lens sees, with practice. It doesn't matter if you're using a compact camera or a DSLR. Focal length is a visual effect. Take a look at a scene with your eyes, then take a look with your lens at the full telephoto (optical zoom only) setting, or the LCD on the camera, and make note of the differences. Now do the same using the wide-angle end of the zoom. Notice the difference. If your zoom goes to only about 35mm, you might not see much difference, because we see the equivalent of about a 45mm angle of view. But if your lens goes wider, you'll notice how much more your lens sees than you do. Doing this comparison will give you a better idea of how short a focal length you'll need to include the whole scene, or how long a focal length you'll need to select just the part you want to fill the frame. Once you figure this out, you'll know more or less what lens to grab (or whether to zoom wide or telephoto on your compact) when you need to act quickly to get a photo.

EXERCISE #2: GETTING TO KNOW FOCAL LENGTHS

Use a fixed DSLR lens, or set your zoom setting to a specific focal length, and spend the afternoon making pictures using that focal length. As tempting as it might be, don't touch that lens. Move closer or farther away to get the framing you want. Work with this one focal length for a week, if possible, until you really understand how to see at that focal length. Then move on to another focal length and practice with that one until you feel completely comfortable with how it "sees."

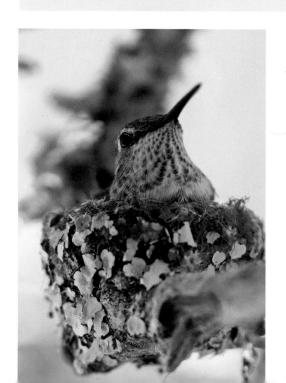

J

this page: We found a hummingbird nest in our yard's tree, and what a delight it was to watch! I used my telephoto lens to avoid disturbing it. This also gave me a narrower angle of view to keep the cluttered scene simple. An aperture of f/5.6, when used on a super-telephoto, creates a very narrow depth of field, which gave me a nicely blurred background.

200–400mm lens at 300mm, f/5.6 for 1/320 sec.

opposite: This field of flowers was so beautiful, but I wanted to include the building and trees in the background to give the image a sense of place. To optimize the depth of field, I tilted the lens down slightly, which made the plane of the scene more parallel to the camera's sensor. By doing this, more of the scene ended up in the same plane of focus. This allowed me to have everything sharp, from the foreground to the back of the image, even though the background had a slight mist softening the view.

24mm lens at 36mm, f/18 for 1/40 sec.

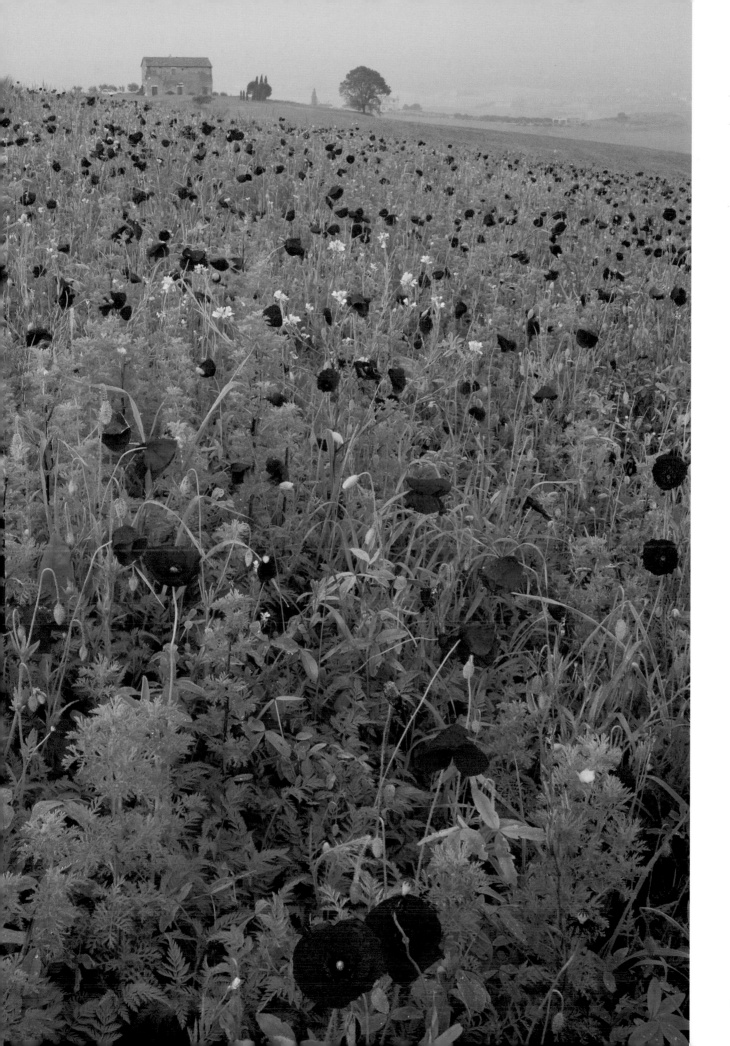

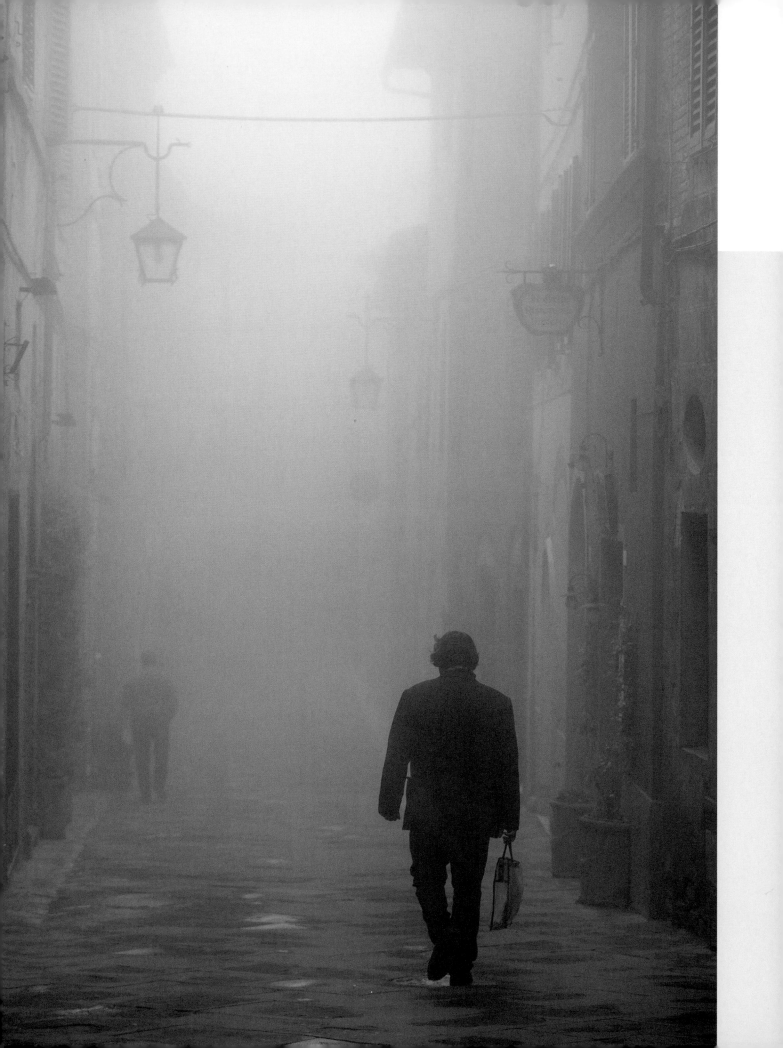

Creating Strong Compositions

H AVE YOU EVER FELT like your day was unraveling, with the loose ends of unfinished tasks and distractions flapping about in the wind? To solve this, most of us typically compose ourselves and organize our priorities to get back on track. Photographic composition is a lot like this. You have all these elements scattered about in a scene, each one possibly a subject, or maybe a distraction. Somehow, you have to bring them all together and create order from the visual chaos. You have to assemble the elements into an arrangement that emphasizes one subject, with a background that works. You have to imagine the final picture and then find it by moving around, up or down, in or out. And nothing in the scene will be neutral. All elements or backgrounds will either support or detract from the main subject. No matter that your high shutter speed stopped the lion in mid-pounce. If the lion is centered in the frame, or there are a lot of distracting elements, it may not be as dynamic a picture as it could be. It's not enough to have a perfect exposure; you also have to find a good composition—hopefully in the right light.

J We had just finished photographing dawn in this Italian hill town when a huge wall of clouds moved in. In just moments, we went from beautiful sunshine to dense fog. Rather than give up and head indoors, I stayed out to capture the residents going about their daily routines in the fog. Here, a man heads off to work, and you can just see someone else down the street as they disappear into the thick of it. Similar scenes occur in any town or city; all you need are the right weather conditions!

70–200mm lens at 102 mm, f/4.5 for 1/640 sec.

WORKING WITH BOTH SIDES OF YOUR BRAIN

While you're looking at a scene, trying to decide how you feel about it and what you want to express, your brain is thinking, "Do I need a tripod? A filter? Should I go with a fast or slow shutter speed? Do I want more or less depth of field? How's my background? Darn, there's a branch sticking in the edge; should I move higher or lower, left or right? Where should I place my subject? What happened to the light?" Ah, the old left brain/right brain dilemma strikes again. In the midst of that chatter, you can lose sight of what made you stop to create the photograph in the first place. And if *you* lose sight of it, your viewer probably won't find it in the picture, either. It's a delicate dance between the two sides of your brain when you're making good pictures. Your left brain will want to analyze which lens, point of view, shutter speed, and so on to choose, but the image should also be driven by your right brain— your emotional vision and your reaction to what you're seeing. It's a marriage of vision and craft, and you need both to make a meaningful photograph.

When you are first learning photography, it's easy to get stuck on the technical side of your brain as you slowly work through what settings might be best. With practice, you'll master the craft to the point where it becomes second nature, and you won't have to think too much about the settings. You'll just know what you need to do to bring out your vision—the right-brain emotional reaction of what you see.

Trust that you have an inner sense of what feels right and let it help you compose your scenes. Good composition comes with

practice. Practice will get your eye to the point that you just see the composition, or rather *feel* it, and know it's right. It's all about geometry within your viewfinder, the way the shapes of elements relate to each

other, and how they align. The more you practice arranging those things by moving around, changing focal lengths, positioning your subject until it all feels right, the quicker you'll be at creating great pictures.

J | Afternoon light raked across this vineyard and backlit the oak tree and vines, creating a wonderful glow. Contrast between the glowing grass and the dark vines created impact in the rows. The dirt lane draws the eye across the frame up to the tree, so placing the tree off to the upper right gave the image balance.

70–200mm lens at 200mm, f/16 at 1/15 sec.

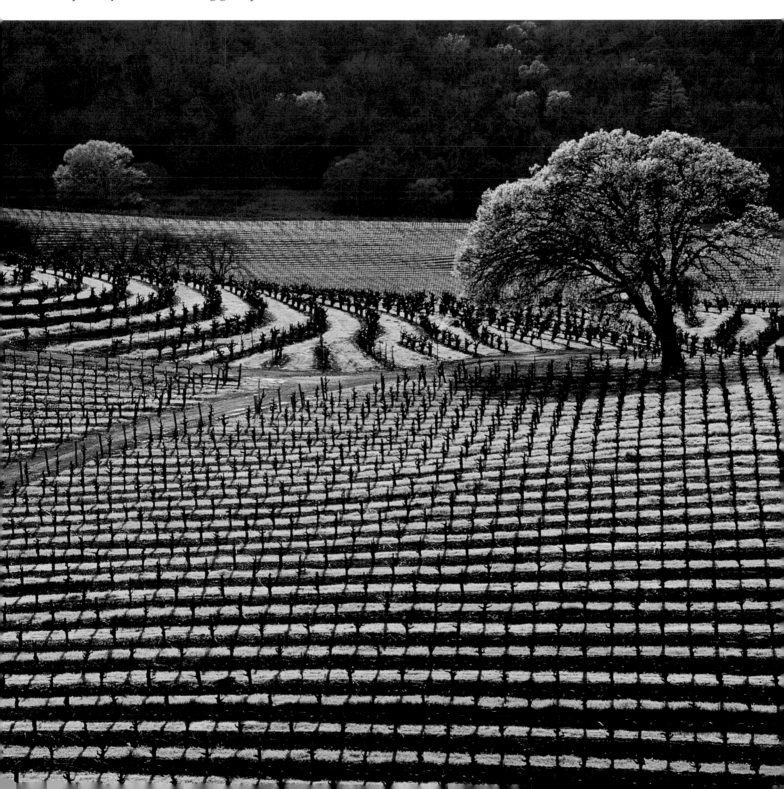

The Rule of Thirds

J

this page: While waiting for a client, I was attracted by the contrast of this streetlight, still in shade, against the office building, which was lit by the morning sun. I attempted to create balance by placing the streetlight in the lower corner, but the pattern of the building turned out to be so strong that it pulls the eye, creating visual tension. Fortunately, the dark tone of the lamppost provided a visual anchor.

Canon Powershot G3, f/7.1 at 1/500 sec.

B

opposite top: This simple composition of a cross in a cemetery makes a strong statement. The placement of the cross was chosen because it faces to the right, so I gave the picture more space on that side.

70–200mm lens at 165mm, f/13 for 1/125 sec.

opposite bottom: Think about the space around your subject when composing a picture. In this case, it was easy—the wonderful reflecting colors created a pattern that filled the space. Your eye enters the frame on the left, and the water carries you to the rock in a nicely balanced composition. The shutter was kept reasonably fast to capture the rippled reflection.

100–400mm lens at 310mm, f/5.6 for 1/50 sec.

Composition really isn't all that difficult, but it helps to understand one basic principle: All of the elements in your frame must balance and support each other, or you'll have visual chaos. For example, many artists and photographers use the principle of the rule of thirds, dividing the frame in three equal parts vertically and horizontally, to create their compositions.

Think of a tic-tac-toe board. The point where the imaginary lines intersect is referred to as a *power point*. You have four of them within the grid, and placing your subject on or near one can make a composition stronger, if it's the right one. How do you know? Many times, putting a subject on the right side of the frame will feel right, because we generally look at an image from left to right, so this way we'll see all the things you want us to on the way to the subject. But simply putting your subject there without thought to all the space around it isn't the answer, either. Sometimes, it works to place the subject on the left. It all depends on what else is in the scene. Do you always want us to feel comfortable? Maybe visual tension will make your picture more exciting. And do you want all of your pictures to look similarly composed? Let the subject speak to you, and the elements around it guide you into creating a composition that works for that one picture. Let it be different for the next picture you make. Don't just apply the rule to all of your compositions. As master photographer Edward Weston said, "Following rules for composition can only lead to a tedious repetition of pictorial clichés."

Not everything will precisely fit in the rule of thirds concept, but one thing remains constant: Most pictures fail if the space and elements divide the frame too equally. For us, nothing kills the effectiveness of a landscape photograph more quickly than having the horizon divide the frame in half. By the same token, putting your dog or Uncle Bob in the middle of the frame will make that picture less exciting, too. There are exceptions, of course, but most pictures that succeed in keeping your attention have the space within the frame divided asymmetrically, with one area or element being a clear winner as the focal point. When things are in equilibrium, nothing grabs our attention—or rather, it all does, because it's presented equally. The viewer doesn't know which area is the focal point, and confusion sets in. Don't let "center-itis" attack! Break the tie by dividing your space asymmetrically, and don't divide the frame.

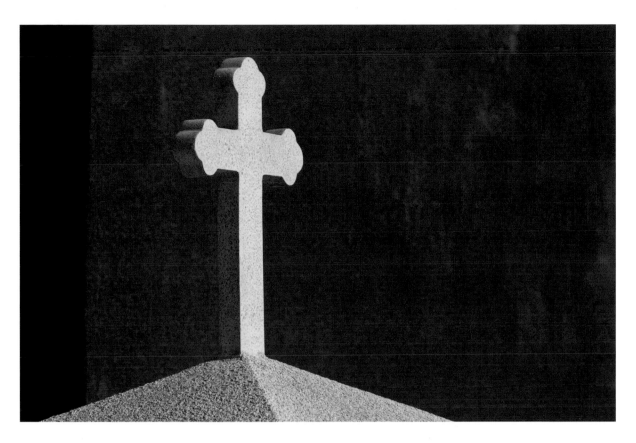

Dividing the Frame Dynamically

As a guideline, a 70/30 split of water/sky or land/sky is a good way to compose a landscape, but which way you go depends on whether you want to emphasize the water or land in the foreground, or the magnificent sky above. This same split is also good for environmental portraits, when you want to include the environment around a subject to tell more of the story. Don't be afraid to push the division to 80/20, or whatever feels right. Each situation will tell you how to compose, if you listen. Go with your gut as you move around to compose the picture.

B It's pretty clear here that I wanted to emphasize the sky, as I gave it much more space in the frame than the land or water. This 70/30 split often works well in landscape images, but don't get stuck composing that way all the time. Each situation will dictate something a little different.

24–105mm lens at 24mm, f/16 for 1/10 sec.

Fill the Frame

A common problem among photographers is that they fail to fill the frame to give the subject enough impact. Your emotional mind can play tricks, fooling you into thinking the subject is larger than it is—especially if it's a whale leaping out of the water, or anything you're excited about seeing. Before you press the shutter, always ask yourself if you are close enough. More often than not, you can then do something about getting closer.

B I photographed this beautiful cherry blossom queen as she sat up on her float in San Francisco. I placed her face just left of center because it created a good balance with the umbrella filling the right side.

70–200mm lens at 140mm, f/10 for 1/200 sec.

Simplifying Your Composition

I made a few quick images of this musician from where I was standing because I didn't know how long the moment would last. They were all like the image at right, using the frame of the bridge, but then I realized that I was attracted to the energy in her posture and gesture as she drummed (and her wild outfit!). By moving closer and creating the image below, I eliminated a lot of the distracting background, as well as some contrast issues. It also brought out the design of her leggings against the stairs. I placed her to the left because she was naturally leaning toward the right and it felt like she might dance across the frame. You feel so lucky when things like this come together.

right: 70–200mm lens at 210mm (crop factor), f/5 for 1/125 sec.

below: 70–700mm lens at 225mm, f/14 for 1/20 sec.

After you make the first photograph that you determine to be the best, continue to explore the subject, zooming in or out to frame the same scene differently, or change your position to change the perspective. Exploring a subject in this way can help you simplify your seeing and your scene. The biggest mistake you can make is having too much information in the frame. Too much clutter and the picture will fall apart. Along with placement of your subject and the space around it, think about making the picture as simple as possible, yet without destroying the story you want to tell. Keep asking yourself if you can make it simpler as a way to refine your vision.

B

We're envious of painters because they can choose to include or exclude whatever they want, and we photographers can't! We have to clean up our scene by moving, or zooming, to get the view we want. The first image, shown at right, is what I had to work with—a very messy background, in which the story of what he's painting is lost. So I moved closer, shifting position to simplify the background. By shifting to the right, I opened up the space between the artist and his canvas so you can see what he's painting.

right: Canon Powershot G9, f/8 for 1/80 sec.

below: Canon Powershot G9, f/8 for 1/100 sec.

Zooming with Your Feet
vs. Zooming with Your Lens

We see people all the time zooming their lenses in and out to find a composition, as if they were playing a trombone! If you want the same perspective but a tighter framing, zooming the lens or switching to a longer focal length lens is the answer, while keeping your same position. Your angle of view will change, but that's it. But if you want to get rid of the tree growing out of the barn roof or Aunt Ellie's head, you'll need to zoom with your feet to change your position. Either method can be the right answer, depending on what you want to accomplish. Ask yourself whether you want to change the relationship of things in the viewfinder, or just make a closer or wider view of the scene. That will tell you whether you need to zoom the lens or move position.

J | I loved the strong pattern of the bricks and windows in this building. By using my feet to change position and get closer, instead of just zooming the lens, I was able to eliminate the white building next door and simplify the image, which emphasized the strong oblique lines and filled the frame to make it just about the pattern that I saw.

70–200mm lens at 300mm (crop factor), f/7.1 for 1/125 sec.

TO CROP OR NOT?

In our workshops, we've seen all sorts of cropped pictures. There's the "I should have gotten closer" crop and the "I wanted this to be a panorama" crop. Then there's the "Oops, I didn't see that telephone pole" crop and the "I didn't have the right lens" crop. In these days of digital photography and computers, it's easy to crop an image and present only what you want. But why not just create the framing you wanted in the first place? Sure, there are times when you can't get close enough—that 80-foot-high cliff between you and the lighthouse presents a challenge, or maybe you don't want to get closer to that large bear—but always ask yourself, "Can I improve this picture by getting closer or changing lenses? Is there anything in the frame I don't want?" You'll be surprised how often you'll end up changing something. It's pretty amazing what you see, once you ask yourself those questions.

Some scenes look better in a different ratio than the 35mm format, and in those cases you may have to crop to get the composition you want. But do plan ahead and compose the scene with the crop you have in mind, so you'll get close to what you want in the final picture. Just remember that unconscious composition can lead to radical cropping. Don't be lazy with your technique. Think about your composition before you press the shutter release. You waste valuable pixels when you rely on extreme cropping. Is that really what you want to do?

To avoid cropping later, tidy up your picture before you shoot. Clean up any garbage in the scene, removing anything you can remove. We've even moved garbage cans (and put them back) when we've needed to. We hear students say, "I'll take it out later in Photoshop." However, it's not always easy to fix these things later, and it's always easier to remove them ahead of time if you can. Clean up your scene as much as possible beforehand.

Another tip is to do perimeter patrol, checking that nothing you don't want is sticking into the frame. When you are emotionally involved in what you're seeing—which is, after all, what we've been urging you to do throughout the book—it's easy to miss the one branch in the sky, or the little fencepost sticking up at the bottom. Get in the habit of asking yourself if there's anything you don't want in the frame, and you'll probably notice things more often.

Pay Attention to the Edge

If you wear eyeglasses, you may have to move your eyes around when up against the eyepiece to see all the edges of your frame. It's hard to always do this, and you can get extra things you never saw. Also, any camera that doesn't have a 100% viewfinder will give you stuff around the edges that you didn't see and may not want. So, a certain amount of cropping on the edges might be necessary. But this sort of cropping is like getting a trim at the hair stylist—"Just a tad off the shaggy edges, please."

EXERCISE #1: EXAMINE THE RULE OF THIRDS

Put your camera on a tripod, and while using a simple background like your driveway or the sidewalk, place a small object like a rock or leaf at a power point and make an image. Move the object to each of the other three power points and repeat the process. Compare the images. Do you feel that each image conveys a difference in energy? Now, add a small twig to your rock or leaf scene, moving it to different places in the frame and seeing how the picture changes with each position of the twig. This is a very basic composition exercise, but it will help you learn to see how objects and spaces relate to each other in each image you create.

EXERCISE #2: SIMPLIFY YOUR VISION

Sometimes simple pictures have the most impact. A small child's hand inside a larger parent's hand, a tiny flower growing in dry, parched soil—these are simple pictures that express a strong story or feeling. Not everything can be distilled down to an extremely simple composition, though. Storytelling images, like news pictures or event photographs, are much more complex. So are landscapes. Yet even those can benefit from some simplification. Reread chapter 2 to refresh your memory about seeing more clearly and concisely, then go out and make more pictures. Analyze every picture with the question, could I simplify this? You'll be surprised at how often you'll find you could get a little closer, eliminate some distractions, clean up the area around your subject, change your point of view or angle of view, and so on, to make your picture stronger by keeping it simple.

J | *opposite:* I was attracted to the wonderful textures and patterns in this wall, and as I walked along I came to this little opening where someone had placed flowers. I positioned them in the lower left and gave a lot of wall space around them to make them feel small and delicate against the stone. Because they are the brightest spot of color, your eye goes right to them, but then it moves out to the reddish bricks along the top and is drawn back down again to the flowers.

24–85mm lens at 85mm, f/9.0 for 1/3 sec.

J | *this page:* When we arrived at these dunes, the first thing I noticed were these three little bushes. I liked the feeling of open space around them. Luckily, there was a passing cloud that I could use to balance the composition. The resulting picture is surreal and expresses how I feel about the scene. It reminds me of a Magritte painting.

24–85mm lens at 85mm, f/16 for 1/40 sec.

Exploring the Light Around You

Have you ever noticed how shafts of sunlight streaming down through the trees in a forest make it look like a mystical place? Or how the golden light of morning can make an urban street look like a movie scene? It's all due to the effect of light and its magical qualities. It's magical in the sense that it can transform an ordinary situation into something extraordinary. Light can make us see everyday things differently. Why is it that we suddenly notice something we may have passed by a thousand times before? Most likely, the light illuminated the object or scene differently for one special moment and we were there to see it. People commonly use the phrase "to see things in a new light"—meaning that when light illuminates something differently, we see it in a completely new way.

This book is about seeing the world around you with fresh eyes. Learning to see and use light well will help you make better pictures of anything around you, whether it's an object in your house or a local landscape. Light is the foundation of all good pictures. Understanding light is fundamental to making good images.

B Translucent objects can look great when backlit. Many cup-shaped flowers, like this California poppy, glow like little lanterns when the sun shines through their petals. To photograph this poppy, I got down on my stomach to be level with the flower. I took a spot meter reading off the deeper hues of the orange blossom, figuring it was a middle-tone orange, which gave a perfect exposure. I also used a Lensbaby lens to soften the edges of the blossom and give it a dreamier look.

Lensbaby lens, 50mm, f/4 for 1/1250 sec.

SEEING LIGHT

When the sun's rays shine down through clouds and light up a statue in a park, or when the rich orange hues of a beautiful sunset reflect off the ocean, it's just about impossible not to "see the light." Yet do you also notice the way the sunlight rakes across a sidewalk, bringing out all the nuances of texture? Do you see the light that shines through a tulip in the garden, or outlines your pet's or daughter's hair? Do you notice how the light changes when a thin cloud covers the sun? Or how the light bouncing off a light-colored wall can create a wonderful glow in a dark alley? It's not hard to learn how to see the characteristics of light and the way light affects everything around you. It's just a matter of becoming conscious of light and all its unique properties and characteristics.

There are three essential things about light that you can learn by observation: its quality, direction, and amount. Take a break and go outside and look at something. Notice the quality of the light that you have at the moment. Is it overcast or bright sun? Are the shadows strong or soft? Do you have almost no shadow on things? Now look at the light's direction. Is it coming from behind the object (backlighting it), or from the side? Last, what is the amount of light? Is it bright, or a low level of light? Are there light-colored objects reflecting the light more than other things? Are there shiny surfaces reflecting the light? Is the light making anything stand out in the scene? This may seem like a lot of questions, but it's part of the process of learning to see light.

B | Bright, diffused light is often the best for close-up photography of flowers and plants, as it provides a more even range of light than sunlight yet still creates some contrast. This makes indoor conservatories and botanical gardens ideal spots to photograph, as they are designed to create this exact type of light. For this image, I used a telephoto lens with a teleconverter and an extension tube, so I could narrow my field of view yet focus close. This reduced the amount of background area and created a shallow depth of field, which, when blurred, softened the contrast between the lighter and darker areas of the background.

70–200mm lens with 1.4× teleconverter and EF 25mm extension tube, f/10 for 1/40 sec.

FINDING THE BEST LIGHT FOR YOUR SUBJECT

The best light is the light that accomplishes what you are trying to showcase in the frame. It may create the mood you want, or bring out the features of an object. The two main characteristics of light are *direct* and *diffused*, and which of these characteristics you emphasize will be different for different subjects. For example, you might need strong direct sidelight to bring out a texture, but for a pattern you might be better with diffused light. You will need diffused light for capturing details in a forest, but for a larger landscape, you may want full sunlight or the glow of twilight. The discussion and exercises that follow will help you learn how to determine the best light for your situation.

While walking the dog every morning, we notice the warm light striking the shingles on our garage, creating strong

texture; as we turn the corner, the red leaves at the top of a shrub glow like brilliant lanterns from backlight. Further down, the sun glints off the shiny needles of a pine tree. Are these photographic moments? Not necessarily, but we've trained our eyes to be aware of light and its impact, so we can't help but notice it all the time. Make a point to train yourself to see light by asking these same questions about the light at any given moment and you'll begin to notice things you may have never noticed before: how it reflects off things, how much contrast there is, even what color the light is. You'll begin to see the angle of the light and how it affects surfaces around you, and how the light may lead the eye toward a certain area or object. By using light correctly in your images, you can make it clear to the viewer what it is you want them to see.

J | I spotted this man rowing an outrigger canoe on a river during sunset. I loved the golden light and how it bounced off the rippled surface of the water. I used my telephoto lens to simplify the scene as much as possible and keep the viewer's eye on the boatman. Because the rower's back is illuminated by the sky, not sun, it has a bluish cast, which creates a contrast of color that separates him from the water.

70–200mm at 200mm, f/5 for 1/640 sec.

Identify Your Brightest Tones

Go outside and look at any scene with bright light. Squint your eyes until you see mostly the bright areas of the scene. This will show you whether you have any areas that are dominantly bright and might pull the viewer's attention away from the main subject, as the eye gets drawn to the brightest tones of a picture. If you do, you can recompose to minimize the bright areas. It's great that we can now use the LCD and instantly analyze the light in our scene, but it's even better if you can do that before you rely on the camera, as part of mastering the craft of photography.

B These two images of San Francisco's Victorian houses show how photographing at a different time of day can make a huge difference. Although the midafternoon version shown at left is technically fine, it lacks some of the emotional appeal of the houses shown at twilight, below. For the twilight image, I mounted my camera on a tripod and used a small aperture to create starbursts in the lights. The incoming fog glowed pinkish from the city lights, adding a nice element in the background. For me, the best light was at twilight for this scene.

opposite: 24–105mm lens at 73mm, f/14 for 100 seconds

below: 24–105mm lens at 84mm, f/13 for 20 seconds

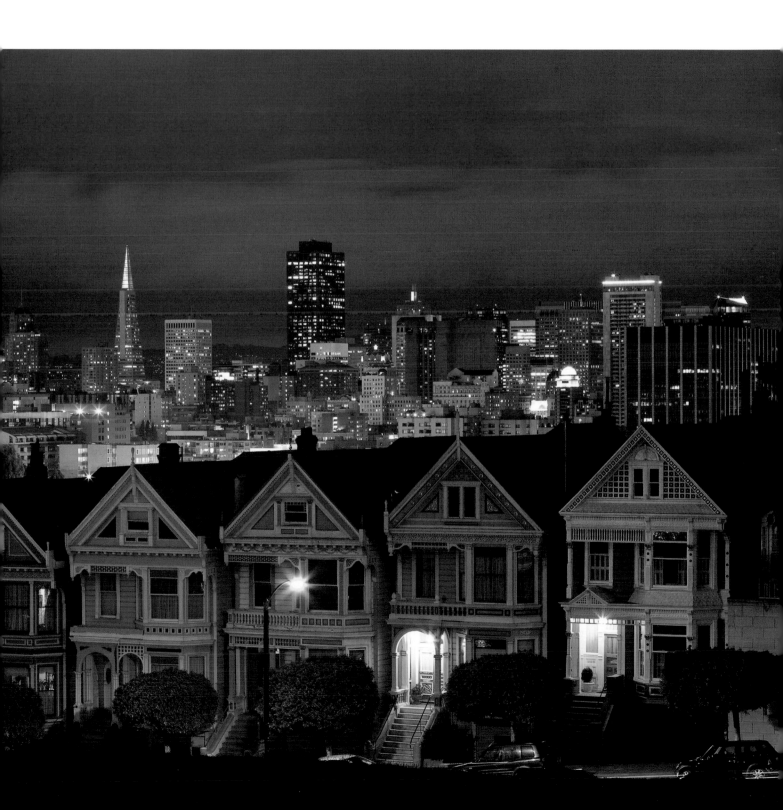

WORKING WITH DIRECT LIGHT

this page: Direct midday light can work well when doing architectural photography, as sometimes you don't want the shadows to interfere too much with the design of the building. But you still need some shadow to bring out the three-dimensional aspect of the structure.

100–400mm lens at 120mm, f/16 for 1/20 sec.

Direct natural light is unfiltered, unblocked sunlight. It's what you have from sunrise to sunset when there are no clouds in the sky. It can be great light if you use it in early morning or late afternoon when the sun is lower and its color more interesting. At midday, that same direct light will be cold, white light, and higher overhead, producing a lot of contrast. You can still photograph in midday light, but you have to make sure the light works with your subject or scene. Reading through this chapter will help you determine that. Some scenes, such

as harbors, can work in either direct or diffused light, as can flower meadows and gardens. It all depends on your position relative to the light and your subject's position.

Because it's so strong, direct light can shine through flower petals, leaves, and even clothes on a clothesline to create a backlit glow that is wonderful to photograph. People's hair and animals' fur take on a great halo of rim light when backlit with sunlight. Even a street scene can be made more dramatic using strong backlight. When direct light comes from the side of your subject or scene, it brings out texture, and when the sun is low in the sky, it will elongate shadows and make them a strong element in your frame.

opposite top: The midday sunlight in February was low enough in angle to sidelight, or skim the surface of, this locomotive in southern California, emphasizing its emblem and giving it dimension against the old train's surface.

100–400mm lens at 220mm, f/16 for 1/25 sec.

opposite bottom: Our dog, Mocha, loves water. In spring, there are small ponds that she loves to play in. When she retrieves a ball from the water, she gets out on the opposite bank and shakes off. I wanted to photograph the great backlighting on the water drops, but I didn't want the edge of the muddy pond in the background. By changing my position, I was able to put grass behind her and still get her backlit, the water drops sparkling as they flew through the air.

24–85mm lens at 75mm, f/8 for 1/125 sec.

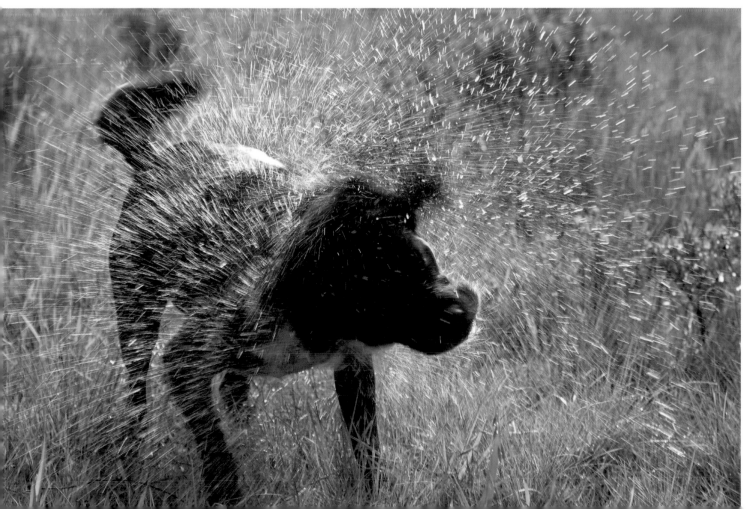

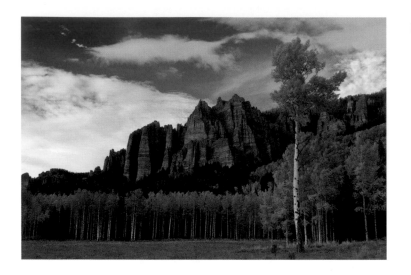

B

These two photographs show how the right light can make such a difference in a landscape. When I arrived, late in the day, the light was just skimming the rock formations and trees. But by the time I set up my tripod and camera, the sun had slipped behind the clouds and the overall contrast was flat, as in the image shown at left. The color of the scene changed, too, now picking up only the cool cast of light from the blue sky, not the sun. While this wasn't bad for some detail images within the scene, like the aspen trees, it just didn't give the overall scene any dynamic impact. I found a better composition while waiting for the sun to return, shown below, with all the drama that made me stop to photograph in the first place. It often pays off to wait and hope the sun reappears.

Both images: 24–105mm lens at 47mm. [left]: f/16 at 1/8 sec.; [below]: f/16 at 1/25 sec.

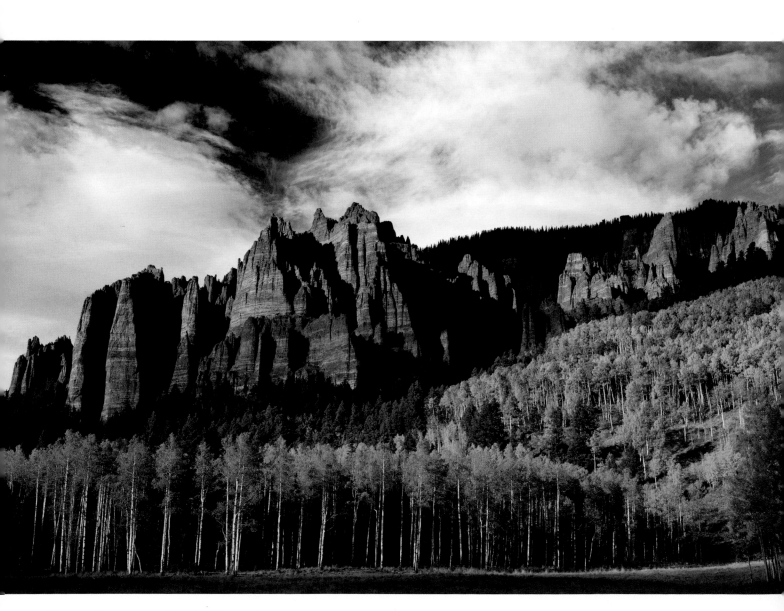

WORKING WITH DIFFUSED LIGHT

When clouds, fog, or mist filters the sunlight, you get diffused light. Many people lament gray days, but this type of light is perfect for certain subjects. We refer to diffused light as "quiet light," because it has a peaceful quality to it and is easy on the eyes. It also reduces contrast, which makes it easier for the camera to record details in both the deeper shadows and the brighter highlights, which in turn makes it possible to see more details in the final picture.

Large landscapes can appear dull or flat in this lower-contrast light, if the clouds are thick and the light is too even. But there are many other things that photograph well in overcast, diffused light, such as macro subjects, intimate landscapes, outdoor portraits, and the details at an outdoor market. You just typically don't want to include the sky, unless it's a dramatic cloudy day.

B Window light, or in this case, light bouncing off a sunny courtyard into the porch, can be wonderful for photographing portraits or still-life subjects. Though still technically diffused, there's a direction to the light shining on this man's weathered face that brings out its roughness.

24–105mm lens at 105mm, f/13 for 1/80 sec.

White Balance Options

The color of diffused light yields a blue cast on cloudy days, which can subdue or flatten the true colors of the scene (part of the reason you may think it's uninspiring). Changing your white balance to Cloudy or Shade will warm the scene back up and reinvigorate the colors. If you just use Auto White Balance (AWB) all the time, you won't notice the color of the light, which for us is part of the craft of good photography. We prefer to control things as much as possible when we're photographing, not leave it up to the camera. Besides, AWB can warm up the cool feeling of a picture, but it might take some of the mood away, too. If it thinks there's too much blue light in a predawn scene of a field of blue lupine, it may warm it up so much that the lupine turns a muddied blue. We keep our cameras set on Daylight balance, so what we see is what we get, and we change it later in the computer if we wish.

J | *this page:* Diffused light can still be strong enough to define form or dimension, such as in this pattern of hardpan in the desert. To bring out the texture of these formations, I waited until the sun was very low so they would be sidelit. The last rays of the sun skimmed the surface with soft light, providing just enough contrast. The blue sky above mixed with the warm pink glow of the sun, creating a soft purple hue on the normally cream-colored dirt. By aiming the lens down, I was also able to bring out the strong pattern, along with the texture.

24mm lens, f/20 for 25 seconds

opposite top: I love photographing the ocean because it is constantly changing. You can stand in the same spot and, without moving your camera, produce innumerable images that are all different. Here, diffused light allowed me to record subtle colors and details that would have been lost in strong sunlight. I stood on a cliff above the waves and used a slow shutter speed to record the immense energy of the waves as they swirled and crashed on the sea palms clinging to the rock below, creating a wonderful sense of motion.

200–400mm lens at an effective 540mm, f/14 for 1/3 sec.

B | *opposite bottom:* Sometimes a scene can be very nice in diffused light. Here, low contrast allows you to see the color and details of the scene. I liked the way these boats lined up at Fisherman's Wharf and that the first boat says "Golden Gate," creating a picture that has a good sense of place.

70–200mm lens at 135mm, f/13 for 1/125 sec.

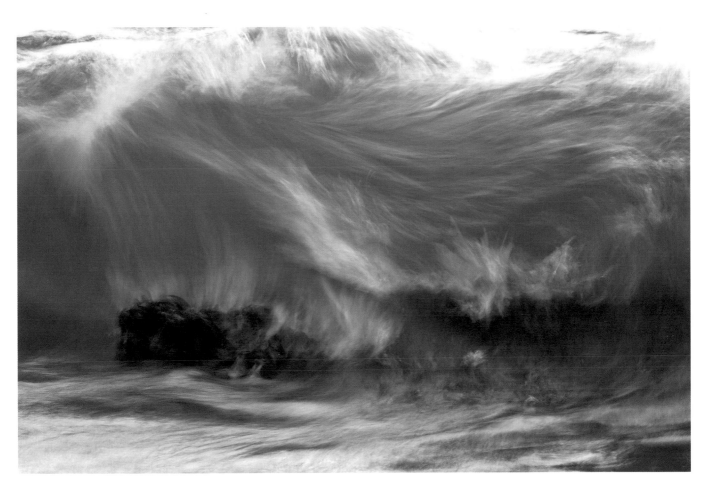

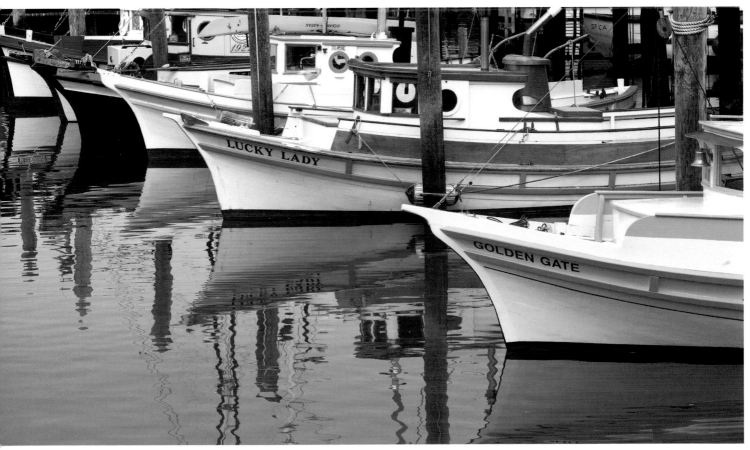

Dramatic Diffused Light

B

The soft, diffused light on this hillside and the drama of the clouds above expressed a cloudy, stormy day. When you have cloud texture like this, including the sky can actually enhance the mood of the scene.

24–105mm lens, at 92mm, f/16 for 1/10 sec.

Fog, mist, snow, and rain are atmospheric conditions that create diffused light. Each carries its own special magic. Fog can eliminate distracting backgrounds as well as isolate your subject from a background, a quality we love. It can create a mood just by the brightness of the fog—darker is more somber, lighter more ethereal and dreamlike. What about mist rising off ponds, clouds rising up the steep sides of hills after a rainstorm, or snow falling on your local park? These are all great conditions of diffused light in which to photograph.

In stormy conditions, you may have ominous clouds and lots of texture in the sky, or you might get shafts of sunlight breaking through dark clouds, creating "god beams." These are some of the best times to be outdoors! Storm light is the most fleeting and elusive of conditions. You never know whether the sun will break through or hail will start falling, and the drama can make an ordinary scene come alive. A nearby church, old house, farm silo, large oak trees, even city buildings can look terrific under dramatically cloudy skies. And don't forget about rainy days, when there are reflections in puddles and people carrying colorful umbrellas and wearing brightly colored raincoats. The wetness saturates colors, too; autumn leaves look richer when wet than when dry. How often have you ventured out in your area during foul weather? It's easy to be motivated to get out into the snow in Yellowstone or into the fog along the moody Maine coast, but your own neighborhood can also be interesting in adverse weather conditions. Use rain protection for your equipment, put a lens hood on if you have one, keep checking the front of the lens for stray raindrops, and you'll have a great time.

Become Weather Savvy

You don't have to become a meteorologist to be a good photographer, but it does help to know a little bit about weather for photography. For example, knowing that with cool nights and warm days there is a good chance you will get mist rising off water can help you decide whether or not to visit your local lake. Knowing that a storm front often means altocumulus clouds means you might want to head toward the landscape you've wanted to photograph, or the coast, assuming you know what those types of clouds are. It's easy to do a little online research and find out that those types of clouds can be great for sunrise or sunset light. Where we live in the Bay Area, we often get fog if the inland valleys get really hot in summer, as hot air draws the moist air in off the ocean. In the Sierra Nevada, this may mean afternoon thunderclouds.

Paying attention to weather will help you recognize the potential for great pictures during different atmospheric conditions. While everyone else is inside by the fireplace eating soup, you'll be capturing the magic with your camera!

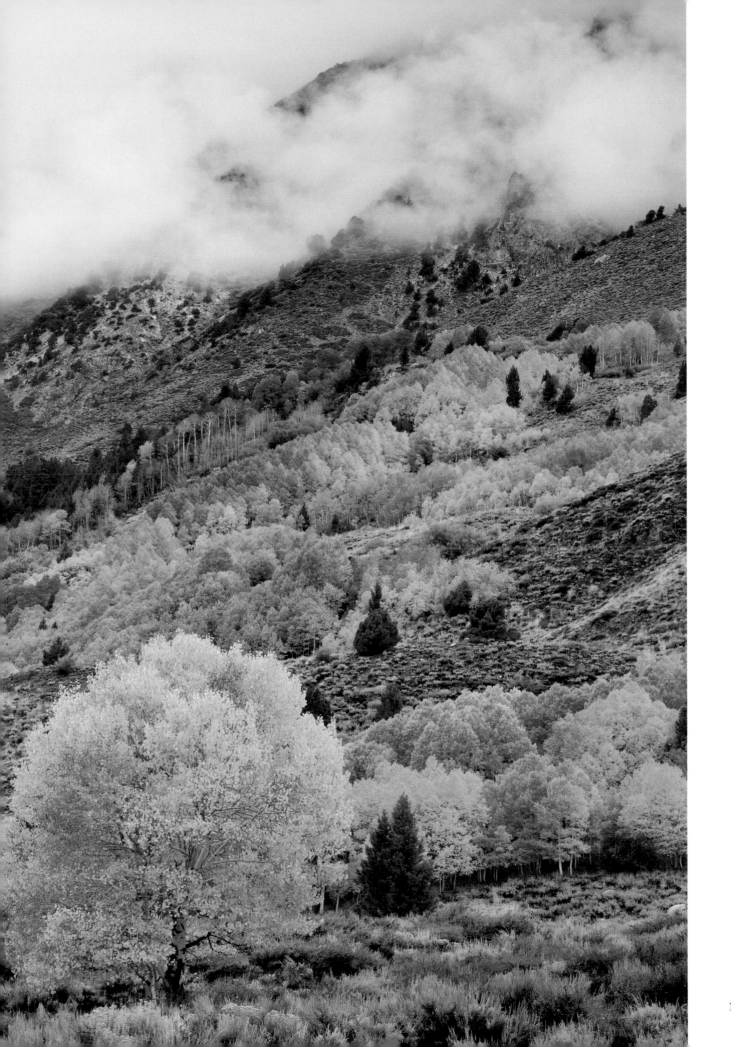

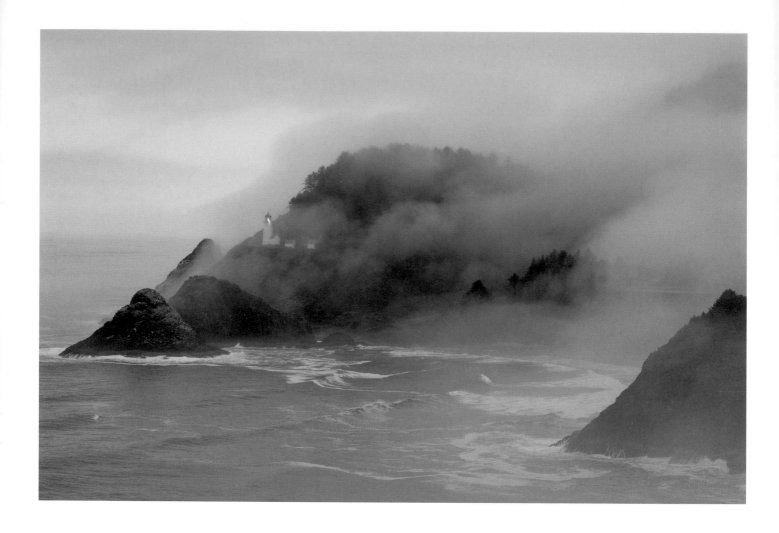

J | The coast is a great place to photograph on foggy days. If you live near a coast, try to get there when the fog is just coming in or beginning to burn off. Fog ebbs and flows on a current of wind and the scene will change a lot during this time. The fog in this image perfectly expresses the mood of loneliness I always feel when I see a lighthouse. The fog is also a reminder of why lighthouses are needed, as the coast can disappear quickly in fog. I waited for just the right moment—when the lighthouse was visible and the beacon of light glowed, yet the fog still obscured parts of the rugged land—to capture the mood of the scene.

70–200mm at 110mm, f/22 for 1/30 sec.

Using Polarizers

Using a polarizing filter is an effective way to get saturated colors by removing the white glare that occurs on overcast days with wet foliage. Don't forget to check out whether it will have an effect on all your scenes, as any sheen—on leathery leaves, wet surfaces, glass, chrome, and so on—can be improved with a polarizer.

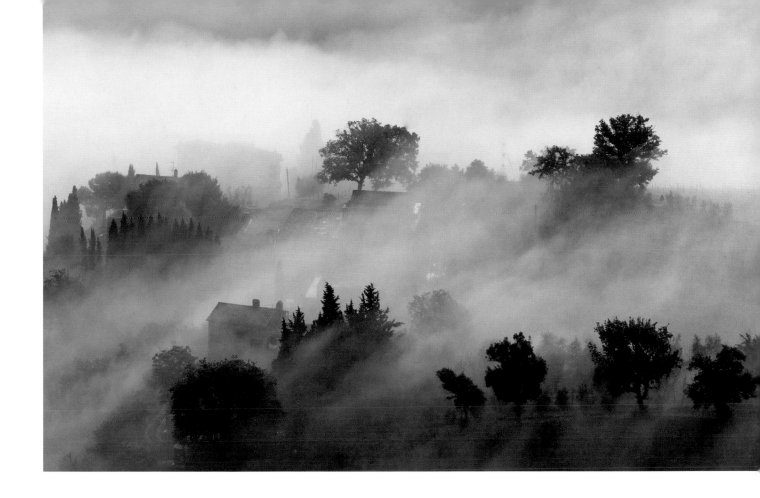

B

above: It's definitely magic when you can get both fog and sunlight to add drama to a scene. I love how the trees cast shadows on the surface of the fog, and the fog looks like it is flowing—which, in fact, it was. Each photograph we made was a little different as the fog moved through the trees.

100–400mm lens at 190mm, f/16 for 1/30 sec.

left: Wet, rainy days can be great for macro details, and I love aspen leaves. This simple composition brings out the pattern of the water drops. The light was already diffused as it was still lightly raining.

70–200mm lens at 200mm, f/11 for 1/30 sec.

Working with the Light You Have

Unfortunately, what we want and what we get are often not the same at any given time. Sounds a lot like life, right? When the light's not what you had in mind, it helps to know how to use the light you have.

If you planned to make pictures of sunrise over a dewy meadow, and you woke up to an overcast sky, you could still go to the meadow, but you'd do better looking for macro subjects—such as spiderwebs and insects—instead of the "big scene." Or, you could head into a garden or the woods to work with diffused light. If you planned to photograph macro subjects but woke to a bright sunny day, you could still work with macro, but it would be best to backlight your subjects rather than use the light straight on, due to the high contrast. Or you could use a diffusion disc—a flexible disc of translucent fabric that will diffuse the sunlight.

There is always something you can photograph with the light you are given. You just need to recognize the quality of the light you have at any given moment and learn what you might be able to do with it. Remember to keep looking at light every day. Notice how it illuminates scenes or objects. Soon you will develop the ability to see light and know how to use it effectively.

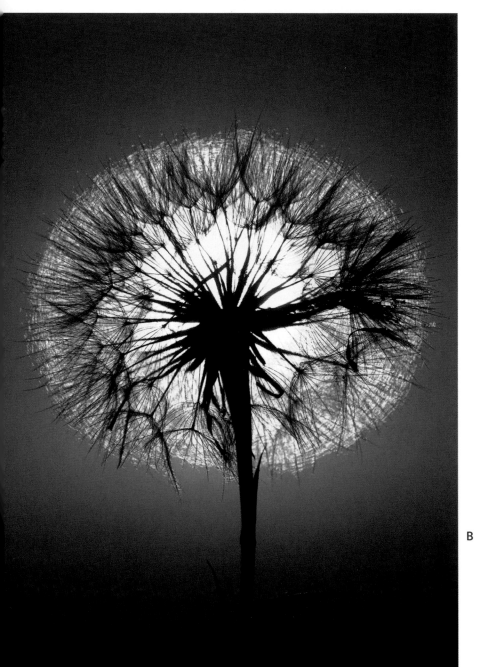

B | A planned sunset over the rolling fields wasn't looking good; the sun was dropping into a dusty layer, weakening the light on the land. Yet the orb of the sun still glowed, so we grabbed some plants that had gone to seed and held them for each other in front of the sun. You learn to think quickly when you've practiced working in all types of light, and you come up with ideas to work with what you have.

70–200mm at 200mm, f/9 for 1/40 sec.

WORKING WITH CONTRAST

For many pictures, the high contrast of direct light can present a problem. Deep shadows and bright highlights make it hard to see the entire scene easily. This shows up even more in the final capture, because while our eyes can adjust to each dark or light area as we scan a scene, the camera can't do that, so you end up with a picture that has very light and very dark areas. We call this "busy" light, as it creates a strong pattern of tonalities.

But contrast is not necessarily a bad thing. In fact, you need some contrast for most pictures to succeed. Contrast can make the subject stand out from the background and helps to define form and shape. A large landscape usually needs contrast to be interesting. You just have to learn when the contrast has become too much. You can also use contrast to make pictures that have strong impact, such as silhouettes. When photographing contrast for effects like this, a technically correct

exposure—an exposure that holds details in the highlights while avoiding clipping too much in the shadows—is not always what you want. Some pictures work better when you underexpose and let the shadow areas go very dark to enhance the contrast of the scene. Don't be too worried about the underexposure side of the histogram. Pay more attention to protecting the highlights and the overall effect when using contrast to make a statement. It's ironic that too much contrast may cause a color picture to fail visually, while a black-and-white conversion may work great. The eye accepts the contrast of a monochromatic image more readily for some scenes. If you find some of your favorite pictures are not working in color because of the contrast, try converting them to black and white, or try photographing them again with a black and white in mind, using the contrast of the scene to help make the picture effective.

J | While photographing this Seattle icon, the space needle, I used an unusual roofline to create a strong negative space. The contrast of light and dark, as well as of the strong angles of the dark shape against the softer, round shape, give the photograph a dynamic energy, and the picture becomes more than another picture of the same old icon.

28–135mm at 44mm, f/10 for 1/250 sec.

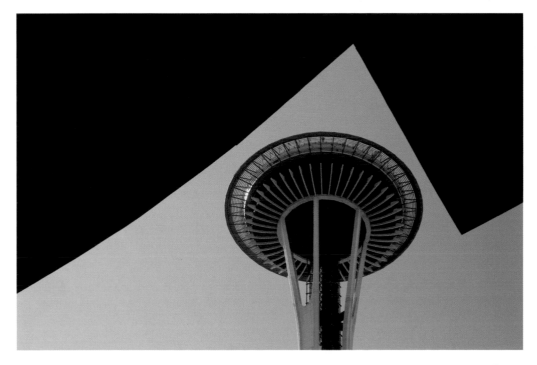

EXERCISES

EXERCISE #1: STUDY THE LIGHT ON A SUBJECT
To learn how light can affect something, set up a plan to photograph the same scene or object under various lighting. Photograph it in the morning, at midday, and in the late afternoon to study the effect of the light during different times of day. Photograph it with sidelight and with backlight if possible. You might have to move around the subject to create sidelight or backlight if the light is not coming naturally from those directions. Study your pictures to see the effects of the various qualities and directions of light. This is a terrific way to learn how to see light.

EXERCISE #2: MAKE PICTURES USING THE CONTRAST OF LIGHT
Try to make pictures that use contrast to emphasize the subject, such as silhouettes against a bright background, or light objects against dark backgrounds. Or, look for strong light and shadows, as shadows can make great subjects for pictures about contrast.

B

opposite: There's something about dead trees that I'm drawn to photograph. The dark silhouette of this tree against the blazing colors of sunset on a large wall jumped out at me as I drove by. I placed the tree on the right side of the frame so you enter the picture and move along the wonderful wall before landing on the tree. Even though the background is the brightest part of the scene, you are pulled to that dark shape of the tree like a magnet.

24–105mm lens at 58mm, f/16 for 1/13 sec.

this page: You never know where your pictures will come from. This man was posing for his wife while she photographed him straight on using a flash. When we turned to see what she was photographing, we saw his silhouette in the evening light and felt that was the better picture. Exposing for the sky turned him and the rocks into dark shapes against the rich hues of the post-sunset sky.

70–200mm lens at 121mm, f/9 for 1/13 sec.

Photographing at Dusk and Dawn

THE TIME JUST BEFORE sunrise and after sunset, often called dawn and dusk, can be just as magical as the sunrise or sunset itself, sometimes even more so. If you want to awaken your vision, go out and photograph during this time. When the sky displays layers of blues and pinks above the horizon, the land can take on that same glow, and rivers, streams, and lakes can reflect those colors, too. In both urban and rural environments, the cool blue glow of the sky mixed with the warm light of streetlamps, shop windows, and lit buildings can turn an ordinary street into an extraordinary scene that expresses a mood of the place.

There are two options for photographing dawn or dusk. You can choose to photograph your subject in silhouette while facing the direction of sunrise or sunset, or you can face away from the sun and photograph the color and light it casts on the scene as dawn shifts into sunrise, or sunset shifts into dusk.

J Dawn on our favorite local mountain, Mount Tamalpais, can be a magical time, especially if fog has rolled in overnight. By getting above the fog line, I was able to record the wonderful colors of both the fog and the sky. Moments like this don't last, as the color fades quickly and the fog can burn off as the sun rises.

24–85mm lens at 45mm, f/16 for 1 second

PHOTOGRAPHING AT DUSK

J When the sun goes down, the blue light of dusk, commonly referred to as twilight, infuses a tranquil, calm mood in many landscapes. Even with all the wave action, this coastal landscape has a peaceful feeling. Because the level of light was low, I was able to use a slow shutter speed to record the motion of the ocean as a soft blur, which helped create a calm mood.

24mm lens, f/8 for 3 seconds

Just after sunset, there is a wonderful opportunity to capture this special type of light. Sunset's warm glow is still on the horizon, with the sky overhead deepening in blue. Bodies of water reflect the sky, adding interest in the land portion of the image. The land is lit with quiet light and has a lower contrast. Depending on the conditions, this window of great light can last about 30 minutes, or longer if clouds are reflecting light back to the land.

If you are photographing street or city scenes, then 15 minutes after sunset is a good time to start, as the street lights and storefronts are so bright that you need a slightly brighter sky to balance them. If it's a fairly dark street scene, a little later into twilight could give you a sky more in balance with this darkness. Experiment to learn which best fits your location.

Including the Moon

If you want to include the moon in your picture after it's high above the horizon, it will be too bright to have any detail once you expose for the rest of the scene. Yet it's still a nice feature to include. So what's the solution? If there are clouds, wait for the moon to be slightly obscured by them, lowering the brightness yet still adding to the scene.

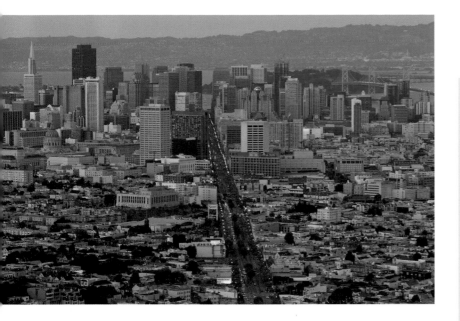

J These two images show how getting the timing just right at dusk can make a difference. The image above shows the city in somewhat flat light with a pale blue sky and has lackluster effect. The sky opposite the sun often gets this way immediately after sunset, for a short time, unless there are clouds to reflect some color. I'm just a little too early in this image for it to have much impact. But just 20 minutes or so later, the sky has changed to a rich blue as twilight arrives, and the city lights glow, bringing the scene to life (below).

above: 70–200mm lens at 90mm, f/9 at 1/8 sec.; below: 70–200mm lens at 90mm, 1.1 seconds

Have Low Light? Use a Tripod!

If you're just learning photography, you might think there isn't enough light to make a photograph at dusk or twilight, but if there is any light at all, the camera can record it. You'll need a tripod to get sharp pictures, as the exposures are typically too long to handhold without significant camera shake. The tripod also allows you to keep your ISO low, avoiding the digital noise that comes with high ISOs.

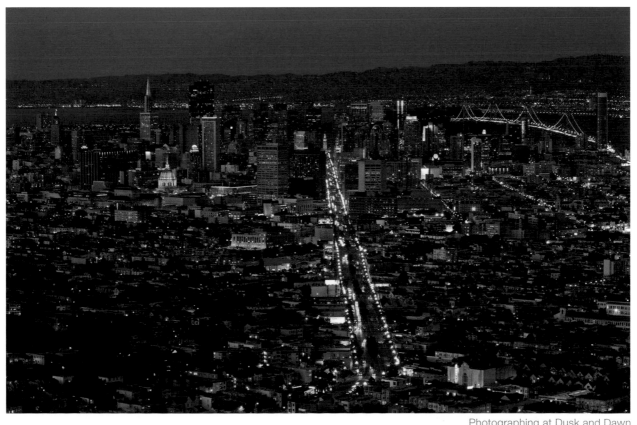

B | Twilight in any city can be magical. Here in San Francisco's Union Square, light from the lampposts illuminated a heart sculpture against the deepening blue sky.

24–105mm lens at 24mm, f/16 for 3.2 seconds

Choosing a Color Balance

Each type of artificial light has its own color temperature, so sometimes it's a challenge to get the color balance you want. Most fluorescent lights in offices and stores will be on the greenish side; if you set your white balance to Fluorescent, those lights might look more neutral, but the sky and other ambient natural light will look a bit purplish. That might actually enhance a reddish sunset sky, but for a twilight blue sky, it usually doesn't work very well. When we photograph skylines at dusk, we choose Daylight white balance to capture the scene as we see it. We might switch to other settings out of curiosity, but we usually keep it on Daylight if we have included the sky in our scene.

B

top: After the sun has gone down, you can get a great glow spreading across the land. When the fog is in at the coast near our home, this view from Mount Tamalpais is one of our favorites at dusk. This image shows the blanket effect that fog creates when you look down on it from a high vista point.

28–135mm lens at 135mm, f/16 for 1.3 seconds

bottom: Twilight along the beach is a magical time, when the warm hues of sunset blend with the cool light of the sky as reflected in the water. I chose to get close to this pool of water, but kept a high enough position to still show the path of water trickling out to sea because it reflects the light of the sky and guides your eye through the scene.

24–105mm lens at 35mm, f/16 for 2.5 seconds

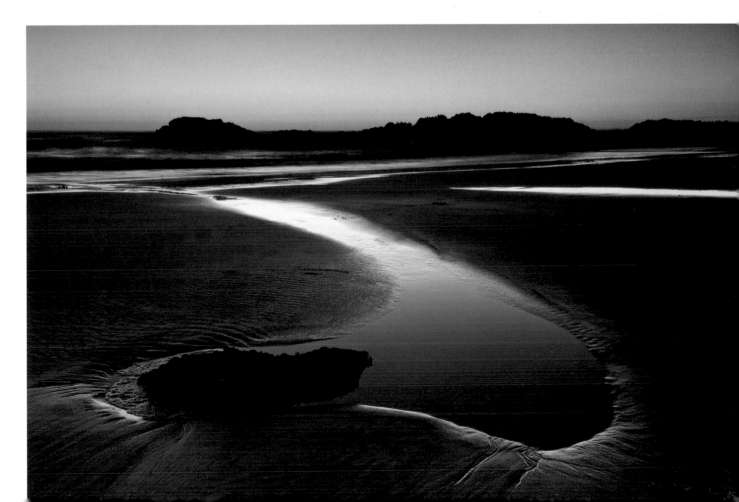

PHOTOGRAPHING AT DAWN

B Sunrise over the wetlands near my home was magical on this morning. Having water reflecting in the foreground gave the picture more interest. Using a long lens optically compressed the distance between the tree and the sun and made the sun larger. I positioned myself to have the sunrise behind the tree for interest and to manage the high-contrast exposure.

500mm lens, f/11 for 1/60 sec.

If you're an early riser and are photographing at dawn, about 45 minutes before the sun rises, streetlamps will still be lit, and shop signs and other artificial lights will illuminate your scene as the sky begins to shift from darkness to a deep, rich blue light. You'll have only about 15 minutes when the sky is in balance with the scene illuminated by manmade lights. Any earlier, and the light from the streetlamps or windows will be much brighter than the dark sky; too much later and the sky will start to pale in hue as it gets brighter, and most of the artificial lights will turn off, leaving only a flat, dull scene with bright sky above it. In a little while, the sun will rise, the blue sky will return, and golden sunlight may light up your scene, creating another, different magical moment.

In the natural landscape, about 30 minutes before sunrise, you can begin to photograph the pretty pink and blue bands of color in the atmosphere that sit above the horizon. The light on the land will be

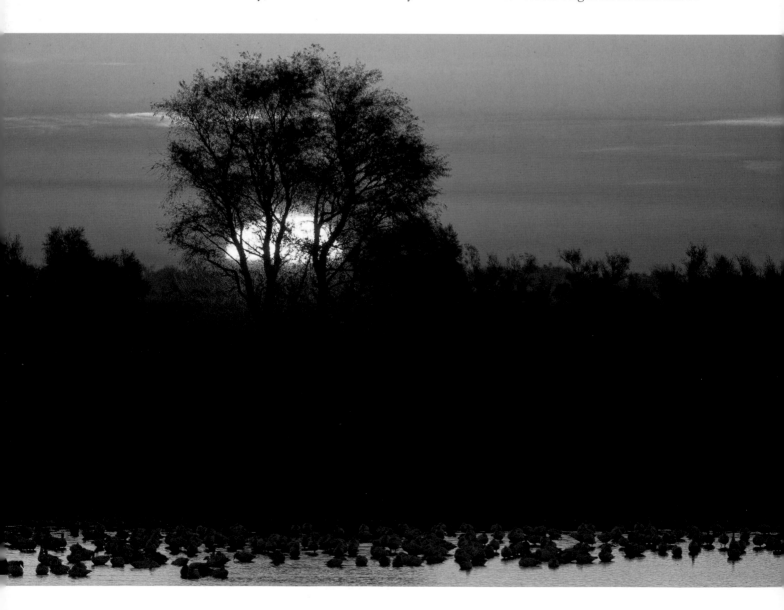

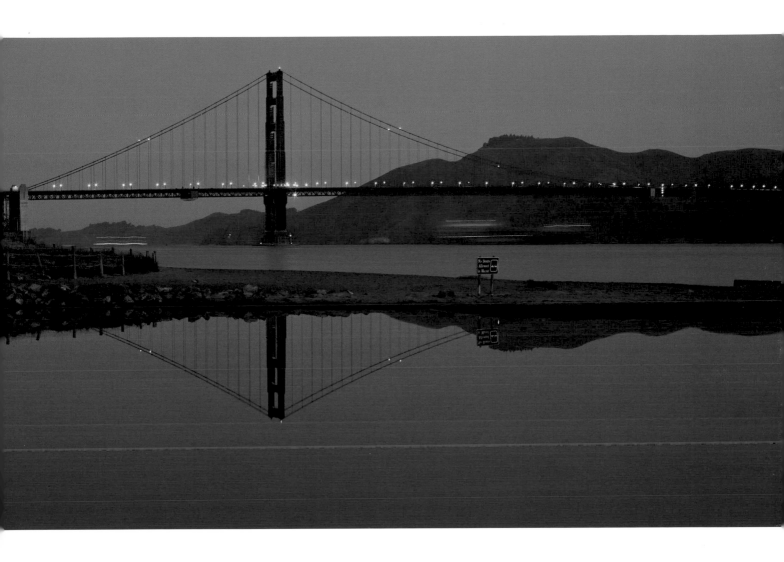

in balance with the light in the sky, making it relatively easy to get a good overall exposure. But the window of opportunity doesn't last very long. As you draw nearer to sunrise, the sky loses those subtle hues and can become too bright for the land below, unless you're photographing a scene with water that reflects the sky, or are lucky to have clouds reflecting beautiful colors. If you have no clouds, you'll just need to wait until the sun rises to have interesting light again for that scene. If you've noticed that some mornings you don't have any color in the predawn sky, it is probably due to

B Predawn light along the San Francisco Bay was beautiful on this morning. With no wind, the cove reflected the bridge, creating a tranquil scene. I set up my tripod and chose a small aperture to optimize my depth of field. Because of my slow shutter speed (due to the low light level and the small aperture), a passing ship left only trailing lights against the background hills. The small aperture also turned the bridge lights into sparkling starbursts.

24–105mm lens at 73mm,
f/14 for 25 seconds

atmospheric haze, moisture, or dust. Smoke can often heighten the colors at sunrise or sunset, but moisture haze and dust typically subdue the color. For us, it's always worth going out early, as there is a special quality to the morning as the world wakes up.

PHOTOGRAPHING THE MOON

Full moon over the Sierra Nevada in California is a special event. Here, a predawn glow lights the rocks while a full moon sets over the ridge. There's only a short window of time during which you can get light on the land as well as detail in the moon.

300mm lens, f/16 for 1/40 sec.

During the phase of a full moon, you can include the rising or setting moon in your pictures at dawn or dusk. We are always in awe of the full moon rising over a landscape, even if we can't photograph it.

The best time to photograph the rising moon is the night before a full moon, because you'll be able to record the detail in the moon's surface while still having ambient light skimming the surface of the land. The moon's surface and the land are pretty close to the same exposure at that point, but it lasts for only about 20 minutes before the moon gets brighter and the land so much darker that you can no longer get detail in both areas without graduated neutral density filters. If there's a lot of atmospheric dust or moisture, that window of time could last longer, as the moonlight will be diffused.

Sometimes, even the night of full moon can be a good time to photograph. It all depends on exactly when the moon became full. (If it becomes full in late morning, you might be able to use the moonrise the night before and the night of full moon.) The morning after the full moon is a great time to capture the setting moon with light skimming the surface of the land. These are essentially the only times during the moon's cycle that you can photograph it and the land in one exposure and have detail in both areas of the scene.

The moon is lit by full sunlight. If you use the "sunny 16" rule, a guideline that refers to using f/16 at a shutter speed of 1/(your ISO setting) for sunlit pictures, you'll get a properly exposed moon. You can't easily meter off the moon unless you use your spot meter and the moon is large enough to place that spot on it completely. So, if you are photographing the full moon on a clear night with a 300mm lens and an ISO of 400, your setting would be f/16 at 1/400 sec. On a hazy night, you might need f/11 as the moon will not be reflecting light as strongly.

In urban environments, think about including the moon with bridge towers, buildings, and skylines. In the country, include barns, silos, or trees in fields. In the mountains, photograph the moon as it rises over lakes and mountaintops. At the coast, capture it rising or setting over the water. Celebrate the moonrise, and use it to make more exciting pictures wherever you live.

Where Is That Moon?

To find out where and when the moon will rise, you'll need to do a little research. Apps for smartphones make it easy, but there are also many websites that will tell you the time of moonrise and moonset, and the position where the moon will rise (see page 157). These are great tools to help you plan.

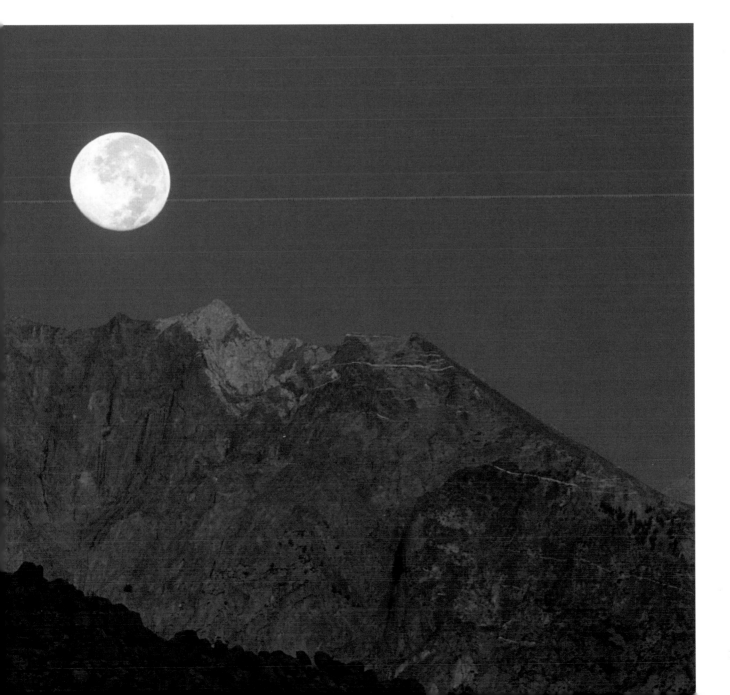

EXERCISE #1: CREATE A STUDY OF DAWN'S EARLY LIGHT

Go out before dawn on a relatively clear day and photograph a scene as the light changes, starting from the deep twilight blue of pre-dawn and making a photograph every five minutes through sunrise. Also try this at dusk, starting just before sunset and photographing all the way through the twilight hour until it's dark. Study your images later to see how the changing light affected your scene.

EXERCISE #2: PHOTOGRAPH THE RISING OR SETTING MOON

On the night before a full moon, find a spot that offers an interesting foreground and where you can see the moon as it rises. Compose a scene including the moon. Use a focal length of 70mm or longer to keep the moon large enough to be interesting. Choose an aperture that keeps the foreground objects and the moon sharp, e.g., between f/8 and f/16. Getting a sharp moon will also require a shutter speed fast enough to keep it from blurring during exposure. A quick test picture will tell you whether you have a fast enough shutter. If necessary, increase your ISO to get a faster shutter speed at your chosen aperture.

J | A long lens is great for photographing the moon with all its details. Even so, you'll generally want to crop in to make the moon a bit larger in the frame. Choosing a night when the moon wasn't full allowed me to convey its three-dimensional surface with one edge shaded by the earth's shadow.

200–400mm lens at 600mm (crop factor), f/16 for 1/160 sec.

B *left:* The sweet morning light at Portland Headlight in Maine is a magnet for photographers. On this morning, I was a local, too, with members of the Portland Camera Club. It didn't look like there was going to be much of a sunrise on this overcast day, but there was a small clearing on the horizon, and when the sun rose into that gap, it bathed the rocks and lighthouse in beautiful light while keeping the sky gray and stormy looking.

24–105mm lens at 35mm, f/16 for 1.6 seconds

J *below:* As dawn approached, the sky turned orange, providing a nice contrast against the blue haze on the mountains. I exposed for the layers of the mountain range while also preserving the color of the sky. Sometimes, the simplest scenes can be beautiful at dawn.

200–400mm lens at 600mm (crop factor), f/16 for 6/10 sec.

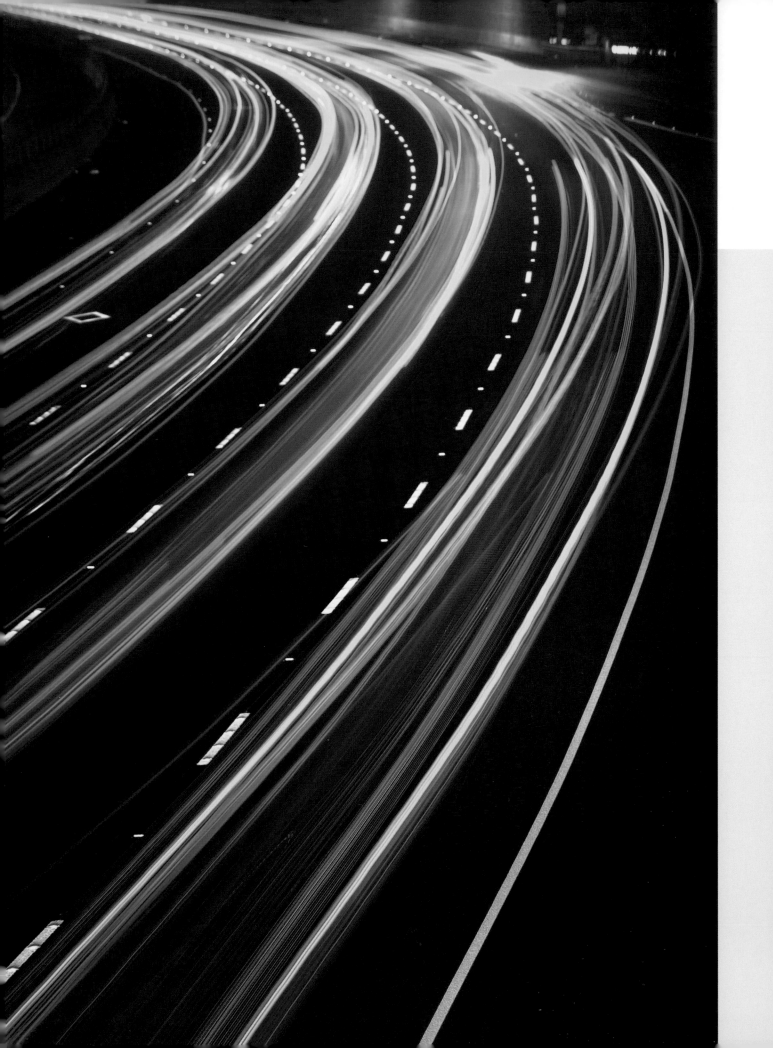

Photographing the Night Around You

MANY PHOTOGRAPHERS WILL PHOTOGRAPH the last rays of the sun, even dusk, and then head home. But once twilight fades, there is still much more to photograph. Even just a few hours after sunset or before sunrise can give you exciting photographs of what your neighborhood looks like at night. Think about the words used to describe the night—serene, tranquil, eerie, surreal, romantic, spooky, dreamlike. You can create so many different moods in your photographs at night. Landscapes typically don't work in the dark of night for obvious reasons, but cityscapes and street or suburban scenes can be terrific.

There are two types of night situations. One is a still-life scene of the night in which nothing is moving, or very little. Then there's the other type, with cars, buses, trains, and people on the go. Both provide creative photographic opportunities. So grab a thermos and some snacks, don warm clothes, and take on the night—photographically!

J | At night the highway can be a fun place to photograph, with all the trailing lights from cars speeding along. I love how you never know exactly what you're going to get when you make pictures like this. I chose to photograph the cars going away from me to get just the reds and oranges of the taillights. White headlights are usually too bright for a scene like this.

70–200mm lens at 200mm, f/8 for 20 seconds

EXPOSURE AT NIGHT

As twilight turns to night, the contrast between the night sky and manmade lights becomes more extreme. There is usually a lot of pure black space in the sky to take into consideration. Try not to include a lot of sky, unless there are clouds or a moon. Fill in the dark spaces of sky with towers, bridges, or parts of buildings that have some light on them. In cities that are affected by strong haze or smog, or perhaps fog, your night sky won't be as dark, and buildings, towers, and so on will stand out more against the sky.

The deep shadows and bright lights create very high-contrast situations, but this is one time when perfect exposure is not as critical; you'll never get the right exposure to completely control light from the streetlamp bulbs and the shadows beneath a tree or bench. Instead, work toward getting an overall balance. You may find that your overall exposure is good but you're still clipping some of the highlights. Don't worry—usually these are just the small points of light from streetlights, security lights, or exposed bulbs. If they are large and noticeable in your scene, though, try to leave them out of your composition altogether.

The best way to figure out what your scene will look like and what problems you might encounter is to make the picture using evaluative metering mode and analyze it on the LCD, paying attention to the overall balance of light. Remember though, it's okay to have darkness in the picture; after all, it *is* dark outside! You just want to watch that the dark spaces—or the bright lights, for that matter—don't overpower the image. If they do, consider changing your position or your framing to minimize them.

As you experiment with night photography, studying what you've done and what the problems were, you'll learn which pictures work in the "dark of night" and which work better if photographed just a tad earlier, at twilight possibly, as well as how to compose night scenes more effectively.

Safety First

For night photography, think about safety. Let family or friends know where you are going and when you plan to return. (And call them when you have returned, or at least the next morning, so they don't worry!) Consider going with a friend. Carry a good flashlight and spare batteries, a fully charged cell phone, a GPS unit if you need it, and some basic things like water and snacks. Wear layers to keep warm in the chill of the night, and good footwear.

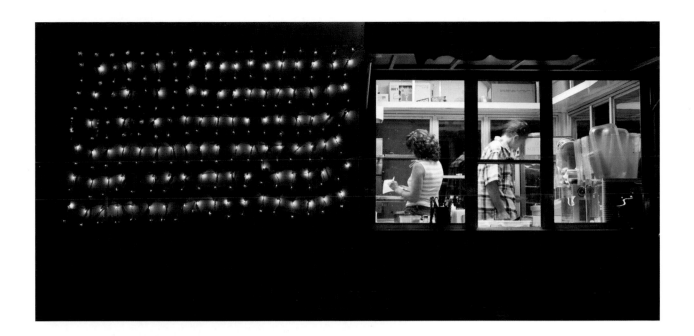

B *above:* This picture of a neon flag and the lit windows of a pretzel stand at a local fair grabbed my attention. I took an evaluative meter reading, then underexposed by 2–3 stops to keep the interior from overexposing. I had to adjust the picture in postprocessing so you could read the dimly visible SOFT PRETZELS sign below the window.

16–35mm lens at 25mm,
f/8 for 6/10 sec.

J *left:* Streetlights can be a challenge because they are so bright against the dark night sky. In this case, however, the trees filled in the night sky space, and because they were coated in snow, they reflected back the warm glow of the lamps, making the correct exposure easier to obtain with evaluative metering.

70–200mm lens at 200mm, f/4.5 for 1/160 sec.

STILL-LIFE SCENES

B | It was a clear night on the Baltimore harbor, with very little wind. But as in most major cities, there is a layer of smog that the city lights bounce off of, keeping the night sky from being totally black. The factory's lights illuminated the steam clouds and smokestacks. A slight breeze above gave some expression to the vapor clouds.

70–200mm lens at 165mm, f/16 for 15 seconds

Still-life street scenes take on a certain magic and mystery when photographed at night, because unless you bring in a ton of additional lighting, you'll always have areas of dark, moody shadows. When devoid of people or moving cars, nighttime streets have a quiet feeling and appear surreal.

Other times, with lit windows showing restaurants full of people, the scene can be almost cozy. The night offers many moods, and still-life scenes of town are fun to create.

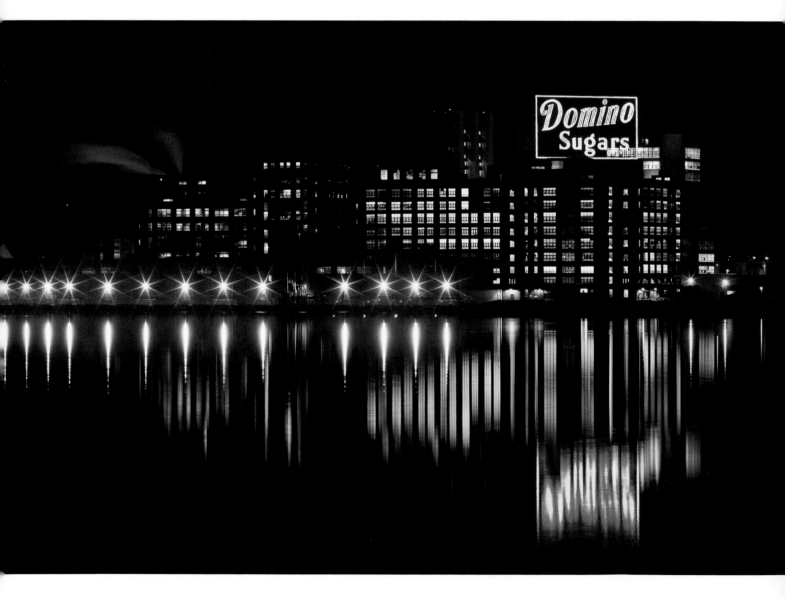

SCENES WITH MOVING OBJECTS

There are a few ways to deal with exposures of moving objects at night. First, you can put your camera on a tripod and do long exposures with small apertures to maximize depth of field, in which case the moving objects will blur quite a bit. Alternatively, you can use wide apertures to get faster shutter speeds and try to freeze the motion of some things, depending on the direction and speed at which they are moving. Finally, you can handhold the camera and use any shutter speed you want, with very interesting results! Eventually, all motion will be blurred as it gets darker, which is part of the fun of photographing at night. Slow shutter speeds will render anything moving in your night scene as a blur. Car headlights and taillights will come out as streaks of light. Generally, taillights are more pleasing than headlights as they provide color and aren't as intensely bright. Sometimes, because it's too dark to be recorded by the camera, the vehicle itself disappears and you are left with ghostly streaks of light leading through your picture. Other times, you can get a

J By panning on this car, I was able to keep it sharp and let the town lights behind it become a wash of color. It's as if the car is driving through a field of lights. The dotted lights are the result of fluorescent lights as they cycled off and on. The deep blue at the top of the frame is the twilight sky about 20 minutes after the sun had gone down.

24mm lens at 36mm, f/6.3 for 4/10 sec.

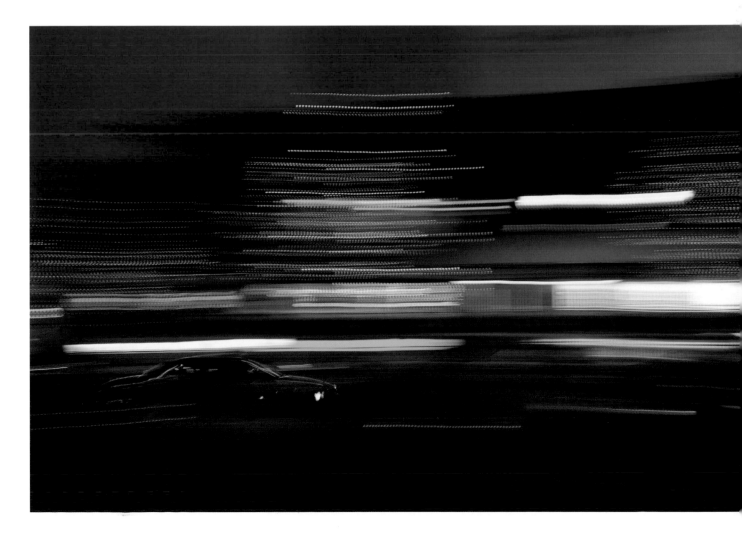

balance in which the vehicle shows and the streaking lights are also there. To try this, stand on a street and count how long it takes a car to go through the entire area you have chosen. If it takes 3 seconds, start with a 4-second exposure. (If you use a shorter shutter speed, the lines will not be continuous and may end in the middle of your image.) Open your shutter just before the car enters the frame to get continuous streaking. There's more than one way to do this, so experiment. Each picture you make will be different, but you'll get an idea of what you need to do to get the effect you want.

You can pan (see page 56) your moving objects, too, which will give you another effect—a sharper, more defined subject with great blur to the background. When there are neon and other manmade lights behind your subject, this can create a terrific result.

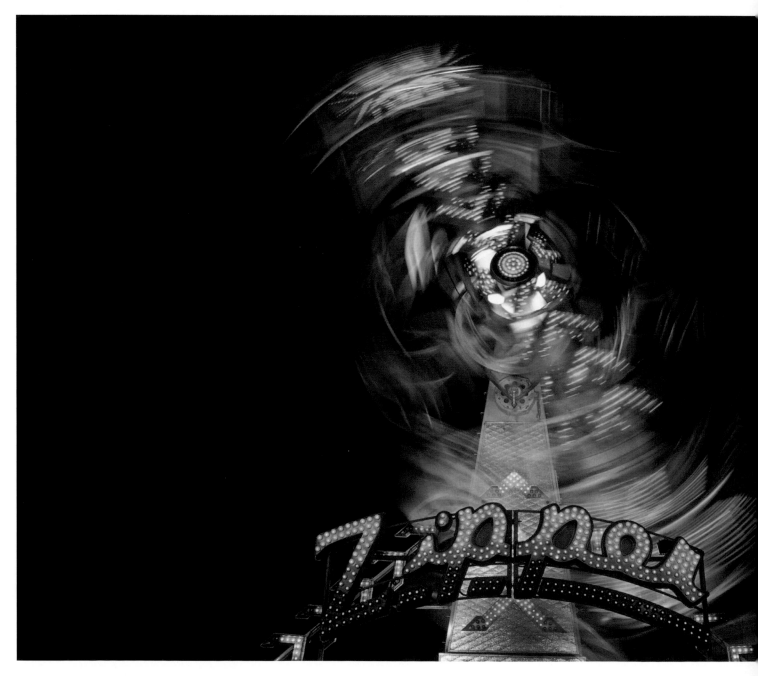

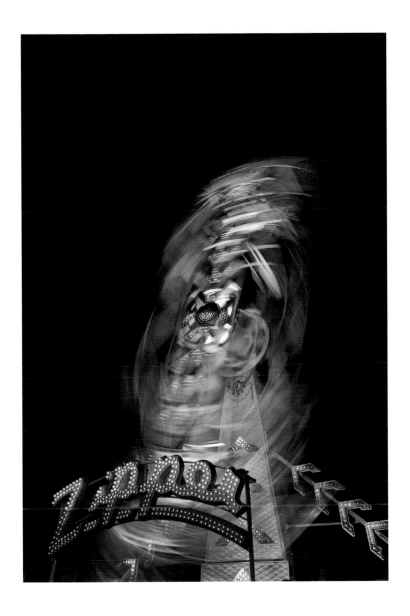

B *this page:* I photographed the Zipper, a ride at our local fair, at twilight to capture the warm colors of the ride against the deep blue sky.

24–70mm lens at 70mm, f/11 for 2 seconds

J *opposite:* After twilight was just about gone, I did a picture of the Zipper as well. I knew that a slow shutter speed would express the ride's moving and shaking, but I wanted the structure that held the ride down to earth to be sharp. I used my tripod and opened my shutter when the ride began spinning quickly.

25–85mm lens at 85mm, f/8 for 4 seconds

Pay Attention to the Background

Watch your background when photographing at night. Brightly lit windows of shops or homes will overexpose quickly when you are doing a long exposure and, if too bright, could become a distraction. Darker backgrounds may make it hard to see your subject, as it may not separate from the background, and you'll lose your focal point. You just have to experiment to figure out what works best in your situation.

SCENES BY THE LIGHT OF THE MOON

When I finished a workshop late one evening in Yosemite, I went out with a fellow photographer to explore the valley under a full moon, a special time to be in the park. By slightly underexposing the image, I created a more moonlit effect. You don't want a scene that looks too much like daylight if you're photographing at night. Notice how the brightest stars still show, trailing above the rock.

16–35mm lens at 27mm, f/5.6 for approximately 3.5 minutes

If you want to take your nighttime photography even further, consider photographing under the light of the moon—just not with the moon in your picture. On a night with a full or even a half moon, you can photograph the landscape fairly easily and create a fresh way to see your world.

If you live in a very clear, dark environment, you can use moonlight to light your foreground and still get star trails or star points of light in your night sky. We've been successful using a quarter moon to half moon for pictures in the mountains of California, where the air is very clear. If you live in a place that has a lot of artificial lighting, then you will have to go somewhere away from the urban glow. Still, it's worth knowing the technique so you'll be ready when you head out into the countryside or wilderness.

To figure out your exposure, open your lens to its widest aperture, ideally f/4 or wider. Set your ISO high enough to get a 30-second reading, the maximum default on most DSLRs. If you can get a 30-second reading at 2000 ISO and an aperture of f/4, drop your ISO to 1000 for a 60-second reading, or ISO 500 for a 90-second reading (both achieved by using the Bulb setting). Now, you have a usable exposure: f/4 for 90 seconds. If you need more depth of field, set the aperture to f/8. Since that is two stops less light, the shutter speed will have to become 360 seconds, or 6 minutes. This simple approach gives you flexible options in calculating exposure for moonlit photographs. Remember to let your camera cool down between exposures to avoid overheating the sensor.

If there is a full moon, set your ISO to 200 and your aperture to f/5.6 and expose for about 4 minutes (use the Bulb setting and a stopwatch or remote control that has a timer setting). This is a general starting point. Bright snow, sand, or water reflecting moonlight may require some exposure adjustments, but these settings have proven effective under average conditions. With a gibbous or half moon lighting your scene, increase your exposure time to about 22 minutes.

When the lens is focused on infinity, the depth of field will include whatever is beyond your horizon (unless your horizon is relatively close and you're using a long lens). Focus manually just short of the infinity mark on your lens to regain some of that "lost" depth of field. Just be sure you haven't gone too far. Check your focus on a test picture to make sure any objects important to you are still in focus. Sometimes it's easier to forgo a close foreground in situations like this to avoid the depth of field issue; it's hard to tell by the light of the moon what's in focus through your lens. Another option is to go out and set up while there is still light on the land to check your focus, then wait for the scene to become totally lit by the moon. But bring water, a snack, and your iPod, and dress warmly—you'll be there for a while! You can't be in a hurry with nighttime photography.

Long exposures cause digital noise, so use noise reduction in the camera settings or later on your computer. Put your white balance setting on Daylight, as the light striking the scene is reflected daylight, bouncing off the moon's surface.

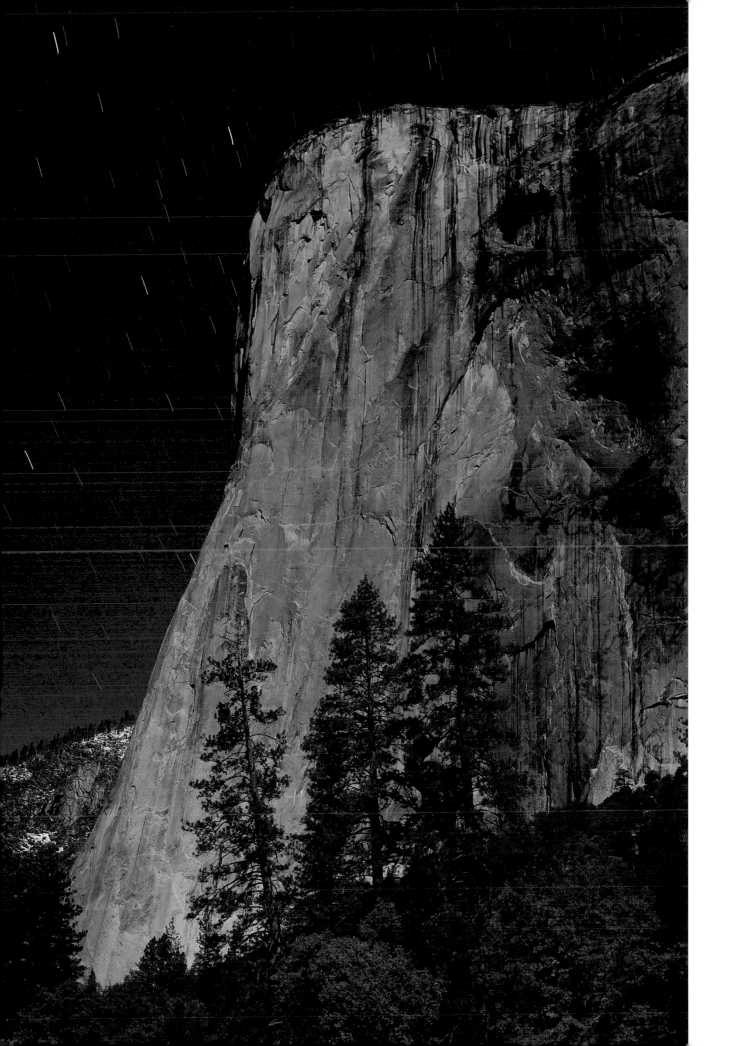

Tips for Photographing at Night

There are many things to think about with nighttime photography, things that don't normally come into play when doing daytime photography. Here are a few tips that can help you get good results.

◈ If you use flashlights or auxiliary flash to light part of your scene, be aware of the highly reflective surfaces on bicycle reflectors, running shoes, and certain outdoor gear, as they will really distract the eye.

◈ Using a small aperture on a wider-angle focal length will create starbursts on any direct light source, such as car headlights, streetlamps, spotlights, and sports stadium lights. The starburst can really add impact to a night picture, but be careful: You might also get flaring from those lights.

◈ Remove all filters from the lens to reduce flare from bright lights striking the lens front.

◈ To combine multiple bursts of fireworks in one image, open the shutter on the Bulb setting. Uncover the lens during a burst, then cover it up again, and then repeat until you have three or four bursts on the one exposure. You generally won't overexpose the night sky. You can also do a multiple exposure if your camera allows that, opening the shutter each time you hear the *whumph* of a firework being launched, and closing it after the burst fades.

◈ The same goes for multiple cars' light trails. If it's not a busy street and you want more than one set of lights trailing, cover and uncover the lens as cars go by while the shutter is open (on Bulb). Start your exposure with a piece of cardboard covering the front of the lens, and when a car comes down the street, uncover the lens and make your exposure. When the car is gone, or you want to stop the exposure, cover the lens again until another car comes. You can do this a couple of times, but you'll need to underexpose your scene so you don't get an overexposed background by the time you've exposed for three or so sets of light trails. It will take some experimenting, but you can get it to work, and your results will look like a busy street.

◈ When photographing cityscapes, consider the day of the week and the season. Generally, weeknights are good as cleaning crews are at work after people go home. But it's really best in winter, when the sun sets while people are still at work or just getting ready to leave. Office buildings will have a lot more lights on just after sunset. During the summer, the opposite is true. By the time the sun goes down and the sky starts getting dark, most offices will be empty, with fewer lights on.

◈ Don't worry if you get some clipping of small highlights—the center of streetlamps and reflections off glass, metal, or water. These will typically be small in the overall scene, and clipping them is not a critical problem.

◈ Don't worry if someone walks into your still scene; if the exposure is long enough, she will not be recorded on the camera sensor—unless she stops to browse in a window!

The Color of Night

Different types and colors of lights will create interesting effects in your night pictures. Streetlamps might be mercury, sodium vapor, or fluorescent. Shop windows tend to be halogen and fluorescent. Car lights are halogen and incandescent. Bus interiors are a warm, white fluorescent. Experiment with your white balance to understand how it will affect the colors of your scene. For example, with your white balance set on Daylight, fluorescent light will appear greenish, incandescent light a warmer orange color, and sodium vapor a surreal yellow. If you photograph a bus going down a street lit by streetlamps, the light from inside the bus will create a nice contrast against the glow of the background street scene. Wet streets can add much to a nighttime scene, reflecting the colors of neon and other manmade lights.

EXERCISE #1: PHOTOGRAPH YOUR TOWN AT NIGHT

Go out after dark and work with the artificial light to capture a different look at your surroundings, such as the pictures of the sugar factory (page 147) and the speeding car with lights (page 148). Play around with both still scenes and moving objects.

EXERCISE #2: MAKING MOONLIT PICTURES

During the waxing phase of the moon, when it is growing from at least a half moon to a full moon, go somewhere where there aren't any artificial lights, or very few, so the light falling on your subject will be just the moonlight. Your subject could be a lake, a mountain, a grain silo, or a stately tree. Make pictures by the light of the moon.

J At night you always have to watch areas of dark sky and shadows, so it's a good idea to find places that are brightly lit with neon and other artificial lights as this can help fill in the shadow areas. Having lit buildings like these can also help define them against the dark sky.

18–35mm lens at an effective 52mm, f/11 for 1/4 sec.

Resources: Apps and Other Software

WE ALL THINK WE know our home area, if we've lived there long enough. You may know roughly in what direction the sun or moon rises or sets, but do you know precisely? And where will they rise or set a month from now? If you live near the ocean, do you know the tide schedule? If you want to make great photographs, you need to know more about the sun and moon, how the seasons change the angle and position of them, and what effect those things will have on the places you might photograph.

Thankfully, whatever you need to know, there's an app or software application to help. We use apps to determine the times of sunrise and sunset, as well as the moon's phases and rise and set times. We rely on apps for tide information and weather forecasts. Because we live near the coast, we even have an app that tells us what the surf is like so we'll know what the waves will be like for our photographs. We also use apps to help us determine where to focus to maximize our depth of field in a landscape. We can tell what constellations will be overhead at any given time of night, and when the Milky Way will be visible over that special tree in the field. It's exciting to have these resources at our fingertips, and they sure make planning our photography excursions easier.

Here's a list of some of the apps we use on our smartphones. Some overlap information, but we like to cross-check data when preparing for a photo session.

Smartphone Apps

Sun, Moon, and Star Information

- Focalware
- Darkness
- Star Walk

Earth Tools

- Tides
- Surf Report
- REI Snow Report
- Compass
- GPS program of choice

Depth of Field Calculators

- DOFMaster
- Focalc

Other Apps

- Flashlight apps, such as myLite: We use two, one set to shine a red "beam," and the other set to shine white. The red beam is so that we don't lose night vision when doing our nighttime photography.

- iHandy Level: This app helps you level your camera for doing panorama photos. It also uses an inclinometer, so if you know the azimuth of the sun or moon for a given time, you can figure out where the moon will be in relationship to your foreground subject.

- DSL Remote: This will trigger the shutter release on some digital cameras.

Software/Websites

- Google Earth: This is a great computer application. We use it check out the terrain and determine the direction that buildings, barns, cliffs, and seaside coves face. We've even used it to see if there's another way to access a group of our favorite trees in Italy.

- Photographer's Ephemeris: We use this software program to see whether the angle of the sun or moon will strike our subject during the current season and just how the light will fall on objects on the land.

- Farmer's Almanac: This classic is still the best to verify the dates of the full moon, because we've seen different days labeled as full moon on various calendars. The book is still published, but these days we refer to the website (www.farmersalmanac.com).

J Using the Tides app on my smartphone, I was able to find out the exact time of peak low tide and which day would be best for a visit to the tidal pools.

70–200mm lens at 110mm, f/20 for .3 sec.

iPhone Picture Processing

B I first processed this iPhone image using Nik's Snapseed for color, contrast, and other adjustments. Then I used Filterstorm to add a texture layer over the image, and finished it with a border.

There's an unlimited supply of apps for creating artistic interpretations of your iPhone pictures. Some do basic adjustments; others create special textures and "grungy" looks; still others convert your images to black and white, stitch pictures into panoramas, and much more. The list of all the creative apps would be quite long to include here, but for basic processing, two apps stand out:

- Snapseed: Produced by Nik Software, this app allows you to make overall adjustments as well as selectively adjust areas of the image. It also includes special effects and creative borders.

- Filterstorm: Produced by Tai Shimizu, this app allows for overall adjustments, layer blending, masking, creative effects, borders, and more.

Acknowledgments

Every project takes a host of people to make it happen behind the scenes, and this book is no different. We thank you all for your part in making this book happen.

Photography is our main skill, and while we also have the ability to think creatively and write those thoughts down, our editor, Julie Mazur, was an immense help in sorting things out and making the book flow just right. Our designer, Kara Plikaitis, made the art and layout look the best possible, and we're so grateful.

Our circle of friends gave us continual encouragement, and our dog, Mocha, gave her unflinching support as she stretched out on the floor of our offices, as if to say, "Don't sweat the small stuff" when we fretted over how a chapter should flow or what pictures to include.

Our iPhoneography group provided continual inspiration with images that both celebrated the everyday world around us and expressed fresh viewpoints of it.

Our friend Elaine Bachelder put the seed firmly in our heads for this book idea, and we are immensely grateful to her for that.

Index